JOHN STEZAKER

First published in 2007 by the
Rubell Family Collection
95 NW 29th Street
Wynwood Art District
Miami, Florida 33127
United States of America
Telephone: 305 573 6090
Facsimile: 305 573 6023
Bookstore: 305 573 6033
info@rubellfamilycollection.com
www.rubellfamilycollection.com

Published in conjunction with the exhibition
John Stezaker:
Works from the
Rubell Family Collection
organized by the Rubell Family Collection
and curated by Mark Coetzee

Presented at:

Rubell Family Collection
(95 NW 29th Street, Miami, FL 33127)
December 5, 2007 - November 28, 2008

Author: Mark Coetzee
Essays: Mark Coetzee and Barry Schwabsky
Interview: Michael Bracewell
Registrar: Juan Valadez
Book Design: Chi Lam
Archivist and Assistant Registrar: Carolina Wonder
Installation Photography: Chi Lam
Accounting: Liliana Zarif
Biographical Research: Brooke Minto
Copy-Editing: Elizabeth Martinez
Curatorial Assistants: Mark Clintberg
and Kristi Mathews
Preparators: Sonia Alvarez, Juan Gonzalez,
Ricky Jimenez, Richard Kern and Matthew Snitzer
Promotion and Sales: Stephanie Garcia
Museum Educator: Linda Mangual
Office Assistant: Katherine Garcia
Design Assistant: Sergio Alvarez
Promotion and Sales Assistants: Kiwi Farah
and Cecilia Fernandez
Conservation Interns: Anne Blazejack and John Witty
Visitor Services Interns: Yadian Fonseca and Jacob Guerin
Archive Intern: Katrina Miller

Printing and Binding: Imprenta Mariscal, Quito, Ecuador

Distribution: D.A.P. / Distributed Art Publishers, Inc.
155 6th Avenue, 2nd Floor
New York, New York 10013
United States of America
Customer Service Telephone: 800 388 2665
Editorial amd Marketing Telephone: 212 627 1999
Facsimile: 212 627 9484
Orders: dap@dapinc.com
www.artbook.com

First Edition: December 2007
ISBN: 978-0-9789888-3-8
Library of Congress Control Number: 2007926623

The type for this book was set in
Times, Britannic Bold and Baskerville

This book was printed on
Torraspapel CreatorMatt (150gsm)
with white Bristol fine cardboard endsheets (160gsm)
sewn and case bound in 2.5 mm board
covered with Torraspapel CreatorGloss (150gsm)
with a matte film lamination

Printed in Ecuador

JOHN STEZAKER
Rubell Family Collection

December 5, 2007 - November 28, 2008

Mark Coetzee

Contents

CAF

Founded in 1994, the Contemporary Arts Foundation (CAF) is a 501(c)(3) non-profit foundation located in the Wynwood Art District, in downtown Miami, Florida. CAF has been a public-access facility since 1996, and the locus for housing, preserving, archiving and presenting works from the collection of the Rubell family, one of the world's leading collections of contemporary art. In addition, the CAF presides over an in-house research library containing over 30,000 volumes, including many rare texts and periodicals. The library is open to the public.

CAF believes that great works of art are an intrinsically transcendent, elevating, liberating and empowering force, and that the artifacts of our time are the legacy of society as a whole. Based on this premise, the Foundation seeks to prompt social intercourse and debate, an essential freedom of a democratic society, by sharing with the world the physical, sensual and intellectual properties of cutting-edge art.

CAF advances public interaction at the Rubell Family Collection (RFC) by presenting works from the collection of the Rubell family in rotating, curated exhibitions with accompanying documentation, throughout its 27 galleries, new media room and Sculpture Garden, as well as through a variety of educational and community outreach programs. CAF commissions new works of art and produces traveling exhibitions, which are presented throughout the world. In addition, CAF operates as a lending resource for curators and museums.

Exhibition Statement

This, John Stezaker's first major solo show in an American public institution, brings together 17 works that span 28 years of his production and illustrates the variable relation, over these many years, between ground image and insert image. Living in a time where we are, in many ways, the grandchildren of pop-psychology, Stezaker brings together strange, unsettling combinations of images. Combing the aisles of flea markets, used-book stores, postcard vendors, etc., Stezaker's anthropological search filters and selects images that often have a strong sense of déjà vu: Hollywood film stars of a bygone age, postcards of the top-of-the-pops of historical monuments, nature scenes and curiosities. Stezaker then takes these faded images and sets up a composition that often seems to be an arbitrary combination of two seemingly disparate components. Through his obstructions of both action and recognition, Stezaker sets us free to investigate the subconscious, the psychological, the philosophical, free from the actual. All the work in this exhibition is drawn exclusively from the collection of the Rubell family.

Mark Coetzee

Foreword: Rubell Family

The Rubell Family Collection (RFC) is one of the leading collections of contemporary art in the world. Started in 1964, soon after Don and Mera Rubell were married, the collecting group expanded some years later when their children Jason and Jennifer, then quite young, joined their parents in buying and collecting art. Recently Jason's wife Michelle joined the collecting team alongside her husband. The family's extensive collection of works dates from the 1960s to the present.

The collection is housed and exhibited in a converted 45,000-square-foot former Drug Enforcement Agency (D.E.A.) confiscated-goods warehouse. Open to the public since 1996, the collection features rotating exhibitions of work by such prominent artists as Maurizio Cattelan, Marlene Dumas, Keith Haring, Damien Hirst, Anselm Kiefer, Jeff Koons, Paul McCarthy, Takashi Murakami, Neo Rauch, Charles Ray, Gregor Schneider, Cindy Sherman and Luc Tuymans. The institution features 27 galleries, a research library with over 30,000 volumes, a film and lecture theatre, a new media room, a bookstore, a gift shop and a sculpture garden.

Over the last number of years, the Rubell Family Collection has presented large solo exhibitions of such historical and influential figures as Keith Haring and Richard Prince. We have also presented solo exhibitions of a new generation of artists, like Franz Ackermann, Francis Alÿs, Hernan Bas, Eberhard Havekost, Jim Lambie, Andrea Lehmann and Andro Wekua.

RFC operates as a public institution with a strong policy of loaning works to other institutions to support their exhibition activities. Some recent loans have gone to the following institutions: The Hayward Gallery, London; Kunstmuseum Wolfsburg; Modern Art Museum of Fort Worth; Museum of Contemporary Art in Los Angeles; The Museum of Modern Art in New York; Schaulager in Basel; Tate Modern; and Whitney Museum of American Art.

In addition, as part of its exhibition services, the RFC regularly produces exhibitions that travel from the CAF in Miami to museums, university galleries and other educational institutions around the world, thereby presenting the work to a larger audience. Recent traveling

llection

exhibitions include "Memorials of Identity: New Media from the Rubell Family Collection," which was presented at The Art Gallery of Florida Gulf Coast University, Corcoran Gallery of Art / College of Art + Design, Haifa Museum of Art, Museo de Arte de Puerto Rico, Nasher Museum of Art at Duke University, and Tampa Museum of Art; and "Life After Death: New Leipzig Paintings from the Rubell Family Collection," which was also presented at American University Museum, Frye Art Museum, Kemper Museum of Contemporary Art, MASS MoCA, Richard E. Peeler Art Center, Salt Lake Art Center, and SITE Sante Fe. "Eberhard Havekost 1996-2006: Paintings from the Rubell Family Collection" was presented at American University Museum, The Art Gallery of Florida Gulf Coast University, and Tampa Museum of Art.

The Rubell family is passionately committed to the art and artists to which they respond. As art patrons first and foremost, and as the heart and soul of an innovative collecting institution, the Rubells focus their efforts on acquiring a large body of work from a particular artist, and conserving that body of work for future generations. During focused exhibitions, each of the artists in the collection have several of their works on display simultaneously, offering visitors a complete overview of an artist's oeuvre.

The Rubell family went to great lengths to acquire exceptional examples of John Stezaker's work and this exhibition marks the first time his works have been presented in a major solo exhibition in an American public institution. As always, the Rubells' enthusiasm and support for this exhibition and publication were unfailing.

I am forever grateful to the Rubells for their guidance and constancy, and for always encouraging me to find personal enrichment in my work here. With collaborators and supporters such as these, all of us at RFC can't help but take pride in our work and our mission. Of course, being surrounded by brilliant and provocative art adds to our delight. I trust you too will share in this delight as this exhibition brings the work of John Stezaker to the attention of a larger audience.

Mark Coetzee
Director
Rubell Family Collection
Miami, FL

The Gaze Interrupted

Denying Total Observation in the Work of John Stezaker

Mark Coetzee

The work of John Stezaker goes to great lengths to obliterate one image with another. Stezaker's modus operandi is to take one image—which for sake of clarity I will refer to as the **ground** or base image—and then collage a second image, the **insert** image, either directly on top of, or disruptively through, the ground image. In this essay I will group together some of the different ways he sets up this relationship.

This exhibition brings together 17 works that span 28 years of Stezaker's production and illustrates the variable relation, over these many years, between ground image and insert image. Immensely articulate about his work and the many interpretations of what he does, Stezaker has been sure to document his creative process through extensive interviews. Although not well known in America— something I hope this exhibition will remedy—Stezaker's influence has been felt consistently both here and across the pond for as long as he has been working. Stezaker has dedicated himself to teaching at the Royal College of Art since 1990, and like many with this calling, sometimes the public acknowledgement of their artwork is less prominent than their passing-on of ideas and training. Talk to any artist of a certain generation and they will wax lyrical about Stezaker's impact as a teacher: Varda Caivano, Gillian Carnegie, Nigel Cooke, Peter Doig, Chantal Joffe, Isaac Julien, Idris Khan, Chris Ofili, and Jane and Louise Wilson, to name a few.

The Gaze Interrupted

Living in a time where we are, in many ways, the grandchildren of pop-psychology, Stezaker brings together strange, unsettling combinations of images. Combing the aisles of flea markets, used-book stores, postcard vendors, etc., Stezaker's anthropological search filters and selects images that often have a strong sense of déjà vu: Hollywood film stars of a bygone age, postcards of the top-of-the-pops of historical monuments, nature scenes and curiosities. Stezaker then takes these faded images and sets up a composition that often seems to be an arbitrary combination of two seemingly disparate components.

Action Denied
Film Still / Tourist Site

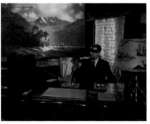

In *Blind* (1979), the earliest work on show, we see a postcard from the picture-perfect Château de Chillon, montaged directly across the upper torsos of a standing male and female figure. Stezaker sets up a strange process of identification, as we are blind to the faces of these figures in much the same way as the third figure, seated, is blindfolded.

Well known for its perfectly positioned situation, idyllic when seen from waterside but impenetrable from mountainside, the castle on one side faces Lake Geneva, and is represented here *la jour d'orage* (the day of a storm). The entire image creates a dark and foreboding drama enhanced by Stezaker's careful obliteration of what might actually be transpiring between the individuals in this movie set. (As we know

from horror movies, it's our imagination that we fear the most.) It was on a similar day with torrential rainfall in 1816, that Lord Byron and Percy Bysshe Shelly first visited Chillon. While touring the castle and its dungeons, Byron was inspired by the story of martyr François de Bonnivard who was imprisoned there in the 16th century. Forced to take cover from the storm in a nearby chateau, Byron began writing "The Sonnet of Chillon," recounting Bonnivard's tale of isolation and imprisonment: "Fetter'd or fetterless to be, I learn'd to love despair. ..." "A sea of stagnant idleness, Blind. ...!"

A personal pleasure is seeing an artist create such visual connections as the sailing boat in the background of the Chillon postcard, and the sailing boat motif echoed on the desk lamp in the foreground of the film still.

One year later, Stezaker creates *The Trial* (1980), again using the postcard of a tourist site as the insert on a ground made from a film still. Perhaps it would be good to remind ourselves of the methodological necessity of the two media that Stezaker combines; both are used in a specific way to create and promote desire.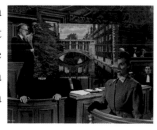

Since the invention of tourism, postcards have been used to construct a hyper-reality of place, perfectly frozen in time. As status symbol, the tourist postcard declares the ultimate snub about place and non-place: I am here and you are not. This endeavor of exclusivity corrupts our basic human need to belong, and so creates a desire for us to visit that perfect place; a place so perfect that an artist's hand is needed to hand tint the image to truly capture its otherworldliness.

The Gaze Interrupted

The film stills that Stezaker appropriates were also used to create desire, first as a promotional tool to get an audience into the movie theatre, but more importantly once they arrive and are standing in line in the lobby, to influence which ticket they buy — almost the equivalent of an online trailer now. Unlike digital technology where still images can simply be downloaded or captured, these film stills are in fact not from celluloid film stock but from actual photographs taken on set. Years ago, when a movie was being filmed, on-set photographers would instruct all actors on set to remain perfectly still for a black-and-white shot. So what we are looking at here in *The Trial* is not an incidental moment captured, as in the fashion of Robert Doisneau or Jacques-Henri Lartigue, but a carefully composed "still" life for the camera. This stillness is perfectly enhanced by the mirrored calm of the Cam River as it flows under the Bridge of Sighs of St. John's College at Cambridge University.

Remember this Bridge of Sighs was named after a bridge in Venice that connects the Doge's palace — the judicial courts of Venice — to the jail across a smaller canal. It was over this covered bridge that the accused were led to interrogation. Look at the ground image: the female protagonist, unknown to us as witness or accused, attracts the gaze of everyone in the courtroom. Through careful placement Stezaker cuts her face exactly in two. So a face photographed front-and-center, we in fact view in quasi profile. As in *Blind,* Stezaker creates an obstruction of action that sets us free to investigate the subconscious, the psychological, free from the actual.

Access Denied

In two works made 25 years later, Stezaker again uses the film still but this time as an insert. In *Cinema 2 I* (2005), we see four males grouped around a draped corpse, bringing to mind Rembrandt's *The Anatomy Lesson of Dr. Tulip* (1632). The yellowness of the image is accentuated by the whiteness of the pillars of a gate to an estate in the Bohnice district of Prague. So here action is evident, but ours is hindered as the insert image acts as a barrier to the ground image, stopping us from entering the pleasures of this 18th-century structure. Curiously enough, many of these estates now function as the psychiatric hospital of Prague.

In *Cinema 2 II* (2005), we see a half-dozen people deep in conversation. Look carefully at the direction of their gazes: each individual is locked onto another across the generously equipped desk that acts as a centerpiece. In the ground image the fountain or water well functions as a centerpiece in the Český Krumlov castle building viewed from the second courtyard. Let's not forget that unlike Hollywood's homogenization of history, the periods illustrated here are separated by 600 years. In both pictures the day is about to close as the sun lays low in the sky, evidenced by long shadows crossing one scene that is devoid of human presence, and the other almost suffocatingly populated.

The Gaze Interrupted

Satisfaction Denied

In the ground image of *Tabula Rasa II* (1983), we see a clergyman not looking at the impressive mountains looming across the expanse

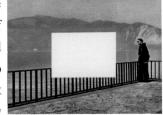

of water but instead averting his gaze to the left. Continuing in our game of private detective we see he wears tinted spectacles. Is he perhaps blind and so unaware of the magnificent vista in front of him? Or is he distracted by something outside the picture frame? Or is it as simple as a bird sitting on the railing right where Stezaker has collaged? In true Stezaker style we will never know! The artist takes a rectangle of textured white paper and perfectly centers it as an insert image, thus forever denying us satisfaction.

Of course we might think of Kasimir Malevich's *White on White* (1918), that hangs in MoMA, or of Josef Albers' *Homage to the Square* series (circa 1960s), but there is a stranger conceptual game happening here. In Duchamp's *With Hidden Noise* (1916), Walter Arensberg hides a secret object inside one of Duchamp's sculptures made from a ball of twine. Duchamp requested that Arensberg never tell a soul—Duchamp included—what the object was, " a diamond or a coin," and it remains a mystery to this day. Does one open the ball of string to determine what hides within, knowing that will destroy the existence of the artwork? Similarly, should we remove Stezaker's white rectangle to satisfy our curiosity (What *is* the reason for the priest's action?) though we will physically destroy the actual artwork to do so?

I think too of *tabula rasa*, the epistemological theory that humans do not genetically inherit mental knowledge or content, but learn this gradually from outside perception. Tabula rasa is deeply connected to the arguments of "nature versus nurture" when it comes to components of human behavior and intellect. So have we solved the mystery? Is the priest gazing at what Aristotle called, this white "clean tablet on which nothing is written"? Stezaker effectively creates a binding dynamic here of nature (the vista) with nurture (the monk and his association with religious dogma and cultural conditioning).

The Portrait that does not Return the Gaze
Portrait / Tourist Landscape / Perfect Composition

In his *Mask* series, Stezaker takes postcards of spectacular views of nature scenes and places them smack over the faces of Hollywood film stars.

It was the Victorians and Edwardians, specifically John Ruskin, who developed the idea of a particular vantage point to look at nature, where all the elements of nature are arranged to form an aesthetic view. Similar techniques are used in theme parks now—that one spot for the "Kodak Moment." A perfect literary example would be E. M. Forster's novel "Room with a View." In chapter six, titled "The Reverend Arthur Beebe, the Reverend Cuthbert Eager, Mr. Emerson, Mr. George Emerson, Miss Eleanor Lavish, Miss Charlotte Bartlett, and Miss Lucy Honeychurch Drive Out in Carriages to See a View; Italians Drive Them," a mismatched band of tourists take an excursion on a specific day to a very specific spot to see a special view.

The Gaze Interrupted

Although the faces of the individuals in the *Mask* series are completely blocked out, we can still recognize their personas. Is it possible that these individuals have become so much a part of our current imagination that even the smallest hint gives away identity? Or does Stezaker's cartoon-like filling-in help us to complete identity?

Let's first look at the colored *Masks*. In *Mask II* (1991-1992), we see a short-haired Shirley MacLaine, her face obliterated by an inverted postcard depicting a double-arched bridge. Curiously, the very thing that the postcard does away with, it also replaces. The dark shadow of the top of the card becomes an extension of her hair, the trees her eyes, and the blue sky peeking 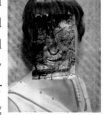 through the arches her nose and smiling mouth. It is almost as if our sense of déjà vu — the familiar — drives us to surreally replace what is not there.

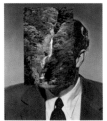 In *Mask VII* (2005), we can barely make out the back of Van Heflin's cranium, ear and chin, but Stezaker's careful selection and strategic placement of the postcard poetically uses the waterfall as both beautifier and describer. The cascade of the water clearly defines a forehead and nose in profile, and as it reaches the river below we can even make out 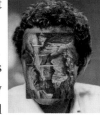 two front teeth and an open mouth.

At first we might see the cave that camouflages Richard Burton's face in *Mask VIII* (2005) as purely abstract, but squint your eyes and clearly you will

see that the dark recesses of the cave represent the eyes and mouth, the stones the teeth, and the stalagmites and stalactites pull together for a grimace.

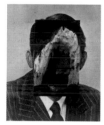

In the two black-and-white *Masks* on show, Stezaker continues to use the cave as both obliterator and describer. In *Mask IV* (2005), the dark interior of the cave describes Gregory Peck's hairline. In *Mask V* (2005), a 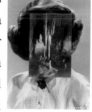 perfectly coiffed Janis Carter sits for a studio portrait at the time of her role in the Columbia Pictures film "Slightly French." The sepia-toned insert postcard reminds me of that Victorian visual pun about vanity: the lady in the boudoir who on closer inspection becomes a scull.

<u>Opposite and Similar Integration</u>
Male / Female Incision

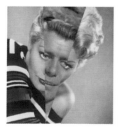

In his *Incision* series, Stezaker begins to consider visual integration of seeming opposites. In *Film Portrait (Incision) III* (2005), he combines images by cutting through a portrait of Kim Novak, the movie star under contract to Columbia Pictures in the 1950s and 1960s, with that of Gene Nelson, the singing and dancing star from Warner Bros. It is rather amusing how Stezaker unifies not only gender opposites, but also dramatic actress with comedic actor, and one competing studio with another.

The Gaze Interrupted

In *Film Portrait (Incision) VI* (2005), Stezaker plays with incision the same way he manipulates insert and ground in his *Mask* series—the dog's shadow completing the actor's mouth.

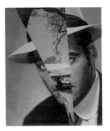

Silhouette
Declaration / Frustration

I am sure we have all experienced the frustration of reading a magazine article in a doctor's or dentist's waiting room only to discover that at the article's end some former reader has cut a coupon out from behind the last page just at the crux of the treatise. That negative space that shows through the next page, I am sure, has incited anger in many as it has in me.

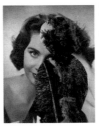

In *Film Portrait (Landscape) VIII* (2005), Stezaker cuts through an artificially lit studio portrait. The confluence of the Vltava and the Sázava Rivers in the Czech Republic does double-duty as a cutout of a female form, half obscuring the model's face. The dark trees create a 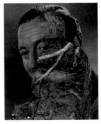 dramatic contrast against the fading female. In *Film Portrait (Landscape) XI* (2005), the male silhouette cutout declares a scene from the Stará Obořa Woods in Hluboká, also in the Czech Republic.

In *Film Portrait V* (She) (2005), Stezaker again brings male and female together in a virtuoso multi-layering. First he cuts out a female silhouette from a portrait of "Latin Lover" Rossano Brazzi, and then collages it on top of a portrait of Ricky Nelson, the sixties heartthrob. In true Stezaker 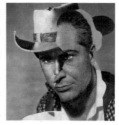 style, the Latin lover's eyes and the heartthrob's become a composite eyeball.

Final Declaration
Towards / Away

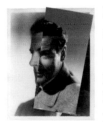 In the two *Untitled* works from 2007, Stezaker allows the window mount to fall short of the edges of his constructions, declaring both his 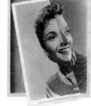 process and intention more clearly. In true Picasso style, we have Dennis King in one work, and Mary Russell in the other, and they both look at us and away from us at the same time.

October 2007
Mark Coetzee
Director
Rubell Family Collection
Miami, FL

Beyond Collage: John Ste

ıker's *Masks*

Barry Schwabsky

What is collage? Nearly a century after it became significant in the artwork of Picasso, Braque, and then others, we ought to be able to give a coherent definition—something a little bit more rigorous than "I know it when I see it." But in fact, the question is not as easily addressed as we may think. First, let's look at the word itself: Literally, *collage* is French for gluing. So etymologically, the word suggests that the essence of the art form lies in that which holds things together. But the dictionary definition shifts the emphasis somewhat, away from the unifying material toward the more heterogeneous materials that are thereby bound together, and introduces the notion of a support as a second unifying factor. The Merriam-Webster Dictionary describes collage as "an artistic composition made of various materials (as paper, cloth, or wood) glued on a surface." If the aforementioned is true, then we can presume that various materials glued together, but not on a single surface, should not count as a collage. But perhaps the opposite is true, in theory if not in practice. According to Yves-Alain Bois in "Art Since 1900" by Foster et al., the upshot of Cubist collage is that "what any element in the work will mean will be entirely a function of a set of negative contrasts." If this distinction is thoroughgoing, then in principle the dismantling of the figure-ground dichotomy ought to imply a dismantling of the dichotomy between surface and glued-down material.

Beyond Collage: John Ste

John Stezaker's collages work rather differently than those of the Cubists, and for that matter they look very different as well. It seems significant that in 2006 at the Norwich Gallery in Norwich, England, Stezaker exhibited a number of pieces titled *Africa*—collages made from photographs of the same sort of tribal sculpture that influenced the Cubists and other early modernists. And yet, this achieved instability in the relation between figure and ground, object and field, remains very much of their essence. Look, for instance, at any of the recent works in his ongoing series of *Masks*. Each piece consists of just two elements—an actor's headshot and a postcard depicting a landscape. This is the first and the most elementary of the reversals practiced in the series. Rather than the landscape functioning as the environment—the "surround" for the human presence—it is the head, or more often the shoulders, ears, and hair around an otherwise invisible head, that forms the surround or frame for the frequently inverted landscape image. What happens next is less elementary and much more uncanny, as the landscape becomes, after all, a sort of face. But this is a face of a peculiar sort; I call it the "face of absence."

To understand how Stezaker arrived at making the *Masks* series, it's worth looking at a few of his collages from 1982. I'm thinking in particular of two that were exhibited in 1990 in Frankfurt, and are reproduced in the catalogue *Film Still Collages*, published the same year. Sharing a title with these earlier works, those *Masks* of 2005 announce themselves as the continuation of a thought that was already underway more than 20 years earlier, but the continuation is not a repetition. This will hardly be surprising to anyone who's noticed that any individual work by Stezaker tends to be a mere fragment of

ker's *Masks*

a project pursued over the long term. The new *Masks* turn out to be quite different from the old ones, and that difference says a lot about what the new ones are. One of the earlier *Masks* consists of a black-and-white photograph of a woman in a seductively low-cut dress. Oddly, she is standing right up against a rope ladder, and in place of her face there is a collaged vintage postcard—a photochromed black-and-white image bearing the legend, "Shooting the Rapids, Killarney." The postcard's horizontal rectangle is dominated by a stone bridge with two arches, so that in the context of the woman's portrait, the semicircles of the arches "click" into place as a pair of eyes, the central pillar between them as a nose, and a large flat stone rising out of the water at the bottom of the image turns into a mouth. The landscape turns effectively into a face, thanks to the striking similarities between the prominent elements in the postcard and the features of a human face. Because these resemblances are so unlikely, they are comical, but because they are so vivid, they are haunting.

The other *Mask* from 1982 is of a man's portrait. A notation on the bottom left informs us that this is the Welsh-born actor Ray Milland. In place of his face we find a vertical image of a cliff, turned upside-down, with an arched bridge in the distance. Inside or through this arch—the image is not easy to read spatially—we see yet another bridge, this one with a pointed Gothic arch rather than a round Romanesque one. The space between the rounded arch and the top of the bridge seen through it form a mouth, while the Gothic arch takes the place of the actor's face. But in this face there are no eyes, as if his face was in the process of disappearing. Bare branches populate the postcard densely. Turned upside-down so that

Beyond Collage: John Ste

their criss-crossing silhouettes lose some of their representational effectiveness, these branches take on a hairy aspect, turning the man in the portrait (Milland) into a werewolf. Perhaps this is appropriate for Milland, who in his later career had been reduced to roles in such cheap horror flicks as "The Man With the X-Ray Eyes."

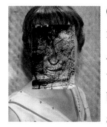

Curiously, the same view turns up in a work Stezaker made a decade later using a different postcard, titled *Mask II* (1991-1992). Here, the portrait is of a woman with short blond hair, posed against a light-greenish background. Again, the openings between the two arches take the place of her nose and mouth, but in this image the branches are not bare; rather, they are dense with leaves. As a result, the graphic surrogates for the mouth and nose emerge in a softer manner than in the earlier work. They are less emphatic visually, and are more of a suggestion than a statement.

A work like *Mask II* points in the direction of the *Mask* images Stezaker has been making more recently. In these, suggestion is everything, resemblance nothing. (Or, perhaps it's no longer even suggestion, but simply the suggestion of a suggestion.) Taking a look at *Mask VII* (2005), for example, the landscape postcard shows a narrow cascade of water pouring down a cleft in a steep mountainside. Coloristically and compositionally, the imposition of the landscape image on the face is much more abrupt than it was in either the *Masks* of the 1980s, or those from the early 1990s. The rectangle of the postcard no longer corresponds in size or placement to the oval of the face it is covering. Instead, it

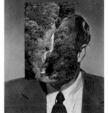

ker's *Masks*

extends to the left of the face and covers part of the space above the actor's head. It might even seem as if one image had been laid upon another arbitrarily, and yet that is not at all the case. There is still a contour to the line formed by the falling water that, in this context, might suggest a nose. And then there is a chute of water just below the main cascade that just might evoke a mouth, simply because of its position. But there is nothing to suggest eyes or even the shape of a head. It is really only in the tenuous semblance of a profile of a rather grotesque-looking nose, that the whole thing comes into fleeting focus as a face. (If I squint hard while looking at it I can just about conjure up an image the might resemble a political cartoonist's rendering of Richard M. Nixon—the bogeyman of my youth.)

Many of the other recent *Masks* lack even this last bit of resemblance, yet all of them insistently evoke a face. For example, in *Mask VIII* (2005), the superimposed image is of a rather fanciful-looking cave filled with stalactites and stalagmites placed sideways across the headshot. Admittedly, the 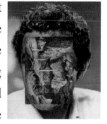 opening to a passageway deeper into the cavern (toward the right of the postcard and therefore toward the bottom of the collage) is placed there intentionally to correspond with the expected position of the mouth, but not by way of any visual similarity. The prominent horizontals formed by the sideways-placed stalagmites and stalactites also work against our perception of a face. Nonetheless, there is some quality of human countenance, however grotesque, disordered or displaced, that remains ineluctably present in this image.

Beyond Collage: John Ste

The same is true of *Mask V* (2005), even though I can't even make out that slight evocation of a mouth that I see in *Mask VIII*. Here we find another cave image — this time in black-and-white, and superimposed on a black-and-white portrait of a woman — presented right side-up. At the bottom there's even the tiny

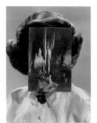

figure of a torch-bearing explorer, surely a personage from the Romantic era of discovery and adventure. Here, the face is present only by its absence, but that absence is more than enough. What comes across is a hollowness, a nakedness that would be truly awful if the image were not also so funny.

In fact, there is a sort of destructive humor to all of this work that the Surrealists would have appreciated; it is this destructive humor that constitutes one of the deep links between them and Stezaker. But there are fundamental differences at work as well, and the clearest way to articulate what may be the most significant of those differences would be to say that no collage-maker among the Surrealists ever worked so profoundly on the phenomenon of perception as Stezaker has. This is why despite all appearances, perhaps even despite all intentions, his art has more in common with the elusive paradoxes of Cubism than with the overt paradoxes of the Surrealists. Typically, the Surrealists worked with what might be called the linguistic aspect of the image. They used an image of a thing to signify, as it were, what the thing signifies. That is to say, they used pictures as words. In his earlier work, Stezaker worked linguistically too, but not literally. Rather, he worked with similes: The arches of a bridge are like a pair of eyes; upside down, a single arch is like a mouth.

ker's *Masks*

But what one discovers, eventually, is that similarity is not based on resemblance. Despite all appearances, it is not based on language, or signs, but on perception. Through three decades of looking at images, Stezaker has discovered not only that the idea of a face need not be represented by a face (which is not surprising), but also that the idea of a face need not be represented by anything even resembling a face. Indeed, "face" need not be represented at all, as long as it is perceived. And it is perceived, in part, by half-forgetting that it is supposed to be a cave. To compare Stezaker's recent *Masks* with his early pieces is to understand that over time he has been learning to see more and more, in less and less. In his earlier works, Stezaker exercised the gift of recognizing similarities. By persistently doing so, it seems he has developed the capacity to produce them through the activity of seeing. In this way, he has redefined the art of collage, which for him is no longer primarily a combinatory activity—a matter of heterogeneous materials, glue, and a surface—but almost a divinatory one, based on shifting the context of images through looking at or into them.

October 2006
Barry Schwabsky

Barry Schwabsky is a regular contributor to Artforum magazine and the author of *The Widening Circle: The Consequences of Modernism in Contemporary Art* (Cambridge University Press, 1997) and *Opera: Poems 1981-2002* (Meritage Press, 2003). He both compiled, and wrote the introductory text to *Vitamin P: New Perspectives in Painting* (Phaidon Press, 2004). Schwabsky lives and works in London, England.

Demand the Impossible a

More

John Stezaker speaks with Michael Bracewell

Demand the Impossible
(March 2005)

Michael Bracewell: Is there a defining statement of intent, do you think, that covers your career as an artist?

John Stezaker: Nothing that's an extrovert ideal; it's more to do with how I feel. I'm dedicated to fascination, to image fascination. And that is a fascination for the point at which the image becomes self-enclosed and autonomous. It does so through a series of processes of disjunction, it seems to me. Firstly, obsolescence in finding the image; then various devices to, in some ways, estrange it, or 'abuse it' as I've sometimes said, in order to bring out that sense of the autonomy of the image. It seems to involve either an inversion, a cutting, or a process that manifestly cuts it off from its

disappearance into the everyday world. I'm very much a follower of Maurice Blanchot's ideas when it comes to image and fascination, and he sees it as a necessary series of deaths that the image has to go through in order to become visible and disconnected from its ordinary referent. I don't know whether that's an ideal, but I suppose it could be a guiding principle.

Michael Bracewell: Do you feel when you're searching out and acquiring the materials for your work, from charity shops or second hand bookshops, that you are assuming a form of psychic responsibility?

John Stezaker: Yes, I do in a way. I'm taking things that aren't usually taken seriously, *very* seriously. And there is often an uncanny dimension to collecting images. You go out looking for one thing, and you find the image that you really should have been looking for. In a sense, it puts you in your place. You realize that your ego's been in the way. Picasso said, "I don't search, I find," and that's true. The 'found image' is a very

Demand the Impossible a

important term. It's not the image that has resulted from a search — it's found. And that's much more spontaneous. It puts the image on equal terms with your own subjectivity; it has a power that overwhelms you. I'm looking for the sublime, in many ways. And I think that the uncanny is a miniature version of that.

Michael Bracewell: Your work is in the tradition of the *flâneur*, for whom there are going to be occurrences in the urban landscape that enable a moment of transcendence.

John Stezaker: Absolutely. And you can go for months and years and not have those moments. You think it's all gone, and that you've lost it. But it keeps you wandering, looking, and not 'searching' but 'allowing yourself to encounter' — there should be a word for that. It doesn't matter whether I've had the images around on my bookcase for twenty years when I start a series; it's always finding an image in a bookshop which starts a new series of thoughts. In a way, what I want to try and do with a viewer is to put them in

that same dazzled, fascinated state that I first encounter the image in.

A very good example, which started *The Bridge* series, was from around 1985 or 1986. I had this dream in which I was floating under a bridge. And for some reason it was an incredibly important image; it disturbed me so much that I woke up. I don't often have very vivid dreams very often, so when they happen I tend to be more attentive to them.

A friend asked whether I had read R. D. Laing's "Voice of Experience." In this, he describes pre-birth and post-death experiences: people who believe they can remember birth, and people who, after resuscitation, believe they can remember what happened to them when they were temporarily dead. [The book is] based on a whole series of interviews carried out by an anesthetist. It turned out that there was a general conformity of these imagined happenings after death to the cultural and religious upbringing of the person.

The exception was one image, which

More

seemed to crop up all the time: they all spoke of traversing a bridge of some kind. Exceptionally some went under, or were sucked under the bridge. This was similar to my dream, and so I started collecting images of bridges and mounting them. I suddenly realized that by mistake I had turned one of them upside down, but then knew that this was not a mistake, but the correct placing of the image. When I turned all the others upside down, I realized that in all of them, unconsciously, I had been aware of this reflection and that all I had to do was turn the image upside down. And the whole series fell into place.

Michael Bracewell: Have you noticed the viewer wanting to affirm in some way what they are actually looking at?

John Stezaker: I thought the opposite would be true. That people would see through the device so quickly that there wouldn't be enough time to entertain that intermediary, unreal space. But in reality it's been the opposite. That's why I've always said that those tiny pieces are actually site-specific pieces, because in a sense, if you put them in a magazine or a catalogue, you have the choice to turn them upside down and therefore destroy the illusion, whereas on the wall you can't do that.

Michael Bracewell: One or two writers have said how your work articulates the classic modernist experience of the city. I think of Ezra Pound's line, "The age demanded an image of its accelerated grimace."

John Stezaker: And Baudelaire's idea of the prose poem, I think, is important.

Michael Bracewell: What was your own art education?

John Stezaker: I went to the Slade. Six years there, undergraduate and post-graduate, in Painting, although I gave up painting, in fact, in the first year. I entered college in 1967, so my first academic year involved the "sit-in," which took place in 1968 **[the key year of violent student protest in much of Europe and America. MB]** which is interesting, because the reason I gave

Demand the Impossible a

up painting was partly political. I was very interested in student politics at the time, and I became exposed to the Situationist ideas from France which were flooding through. And really that's where collage came from, too.

It was a very interesting thing, because I couldn't read French very well, and so a lot of the Situationist International was predominantly a visual experience for me. So seeing these re-captioned images gave me ideas, that this may be another way of thinking about being an artist. But equally it was a very academic course, so it was strangely schizophrenic. On the one hand, I was doing life drawing with Ewan Uglow, on the other I was entertaining ideas from Guy Debord.

Michael Bracewell: So what was the teaching like then?

John Stezaker: Very academic. Based very much on life drawing, although it changed while I was there. '68 changed everything, and so I only got a glimpse of the old establishment. I lived during what most people regarded as something of a vacuum in terms of the Slade's history. Because we started off with the most amazing array of teachers—Richard Wollheim, Professor of Philosophy, I studied with right the way through to post-grad—and he was a marvelous man. I became very involved with philosophy through him, and in fact submitted by postgraduate a dissertation—I think I was the first art student to ever do that, I'm not sure. It was on post-Duchampian art. I was trying to make a relationship between Duchamp and Wittgenstein at that time.

So it was a very exciting time, but I also regret '68 in a way. I feel that what we did then was very damaging. We had Gombrich as an Art History professor, but he never turned up after '68.

Michael Bracewell: Why do you think '68 was so damaging?

John Stezaker: Because we were dismantling the structure totally, with nothing there to replace it. We had William Gregory for Visual Perception, for instance, and all these things vanished after '68. There had been an amazing line-up

More

of intellectuals involved in the Slade teaching at that time, and afterwards there was this emptiness, and it never really recovered. But for me, the one valuable thing I got out of it was coming to terms with some of the ideas of the Situationists—Guy Debord, in particular. "La Société du Spectacle" was terribly important. I struggled with it in French at the time, and then it was published in English in 1969. But his interest in collage as well made me aware of the subversive potential of Surrealism, for, really, Situationism comes out of that tradition, as much as any tradition of political resistance.

Michael Bracewell: How did you envisage the Left?

John Stezaker: I was terribly naïve; I wasn't that interested in politics, really. I became very interested in the image culture. My big problem was, "how can you be an artist in a culture of images?" That was the central question for me, and there were other figures who featured fairly highly. For example, I became familiar with Richter, and friends with Polke. I came back with ideas about painting,

but somehow felt dissatisfied when I started to enlarge up a found image onto a canvas; it seemed an artificial and an unnecessary process. So I was torn, really, between painting and using other means. So in the end, collage became the way through that process. It was a way of manipulating the found image without having to go through this other process.

I was influenced by the political climate at the time; I must have been, because at one point I joined a fringe Maoist group. It didn't last more than one meeting, but there we are.

Michael Bracewell: It's interesting how a political climate can become an artistic enabler.

John Stezaker: I think Situationism generally opened up a new awareness of the culture—that we live in a culture of images. And that was an important realization, that we started to pay attention to something that previously we had treated as beneath contempt, as artists. I don't think Pop Art had really taken its subject matter seriously; it

Demand the Impossible a

was more something to rebound its own formal values off. But what I felt I needed to evolve was a kind of art that genuinely engaged with that momentous circulation of imagery, and I found a way of intervening in that and revealing something about what had become rendered as a sort of collective unconscious in some ways. And that got me interested in Jung briefly, as well. The idea that there could be a social version of the collective unconscious within the media, and for a while I played with ideas around that. So it was a curious mixture of influences at that point.

Michael Bracewell: There also seems to be a deeply romantic sense to your work.

John Stezaker: Oh, totally. I find myself, in the work, trying to find ways in which one can encounter the media image in a way that resonates with that whole iconographical tradition going back to Romanticism via Surrealism, I would say. There is a tradition of fascination for the image, and that is a romantic attitude; something which gives to the image a degree of

autonomy and that's a romantic ideal. Blake was a very big influence, too, on some of my symmetrical pieces.

Michael Bracewell: Was there a breakthrough moment for you in trying to solve this problem of image making in a culture of images?

John Stezaker: Yes. There was a piece I kept in my bedside at the Slade. It wasn't really a piece; there's an interesting story to it. I moved to London when I was 12, and one of the first things my mother did when we arrived was buy a slide projector. They had decided to be modern in the '60s, and they weren't going to keep an old-fashioned photo album, but have a slide projector and have shows of holiday snaps and so forth. With the projector came the image of Big Ben **[at London's Houses of Parliament. MB]** of which the piece was a tiny fragment. There were two figures standing by the Thames, and the piece used just one corner. So it was the slide that was provided with the projector to test it out. And I started doing a painting in my bedroom, projecting this up on to

More

the wall, under the influence of German expressionists, lots of very colorful paint! So when the slide projector was on, and the bedroom was all darkened, it was an absolutely stunning painting. But the moment I put the light on, it was just a horror!

But the image stuck in my mind, and I found it later on, on sale as a giant postcard for tourists. And it was my first 'found image' you might say. I took it home, at about age seventeen, and cut this one particular corner out, and for some reason kept it. And it stood for what I called 'my apocalyptic possibility' for art, and *The End* became the title. I thought, "Could art just be that? Just finding, and taking out of circulation?"

Michael Bracewell: When you enlarge an image, how does this fit in with the processes of your work?

John Stezaker: It's important to me, the enlargement process, apart from the fact that I don't like the detachment from the original. That's my problem with any process, whether it's small or large; I am very fascinated with the original, and it's that point of contact. I like the idea that when people look at a piece of mine on the wall, they are looking at what they might flip through in a second in a bookshop, or might find somewhere in the world anyway, only something has happened to it—some minute thing, like just turning the image upside down—and their relationship with it has been changed. I like that immediacy. But then there also other things I want to explore. And symmetries, for instance, you can't do without some form manipulation.

Michael Bracewell: That tiny readjustment of the 'found' is quite Duchampian.

John Stezaker: I see them actually in Duchampian terms; I think he uses the word 'arrest' or 'stoppage.' All those terms interest me. I think he was the first to be aware of what it is to be an artist in an age of image flows of one kind or another, and that's where I pick up on that moment of interruption. I see the cut as a decisive interruption of that flow in one way or another, whether it's physically the flow of

Demand the Impossible a

cinema and the film still, or whether it's the flow of images in terms of image turnover and circulation. I see them in Duchampian terms of being 'arrests,' or more pessimistically he uses the term 'delay.' How do you inscribe into that fluidity? How do you do something that's fixed, and has that quality of 'contouredness' that art requires for an image to become an imaginary possibility? How do you inscribe that on this complete flowing-away of the world around you? And that, to me, is the central preoccupation of my work. Is it Saint Paul, building his church not on the rock, but on the sands? How do you build a place of contemplation and of transcendence in this space of continuous movement?

Michael Bracewell: Where does that stand in relation to Conceptualism?

John Stezaker: It is the opposite of being conceptual to me. Conceptualism, for me, is an integration into that flow of instrumental communications. For me, it is a disjunction from one's conceptual relationship with things that brings about that image possibility. Blanchot talks about the point at which the image becomes the master of the life that it reflects. He's actually talking about a corpse; the point at which you see a face in a dead person that you've never been aware of before, because the ordinary connection of communication with that face has been lost. And he says that with Breton's 'unuseable objects'—obsolete, perverse, they are fragmented, outmoded. In that obsolence and fragmentation they reveal something of their image quality: they become visible, where otherwise they have been invisible, and simply circulate. "They disappear into their use," is I think the term that Blanchot uses. My aim is to make it appear again, and to make the world visible.

Michael Bracewell: There seems to be a considerable intellectual underpinning to your work?

John Stezaker: There is, but most of it tends to be post-rationalization to be honest. The leaps are made intuitively, and then it takes me often years to find out what it is I've done. And that's usually the way of terminating a

d More

series, and so funnily enough, it has a negative effect. Or rather, it is positive, but it's a way of closing things rather than opening things up, I find.

More
(October 2006)

Michael Bracewell: Could you describe how, for you, a piece that you are working on begins and ends? Is there a common starting point for a piece, or a particular sensation or response that confirms for you that a piece is finished?

John Stezaker: I suppose my practice of collage and appropriation closes the gap between these two moments as much as is possible, between the starting point—finding the image—and its finish, its re-presentation in its altered state. But in practice, mine at least, the gap between these two moments is elongated, sometimes over decades. The two moments feel very different to me though they can be simultaneous and in one sense they are always simultaneous. Dominantly ending feels like a kind of stilling—the image has found a provisional space of repose. The starting point, the sense of an image dawning in the everyday, is felt initially as momentous. I often feel that there is an inability to focus on the image as if it was somehow straying from itself. Pinning it down is the work.

Michael Bracewell: To what extent does the concept and pursuit of beauty come into your work as an artist?

John Stezaker: I like much of what Elaine Scarry has to say on the subject of beauty and find many of her key ideas are directly applicable to what I might call the 'found.' For example, she describes the experience of beauty as a 'tear' within the spatio-temporal continuum of the everyday. I like that description. She describes it as a sudden encounter with the otherness of the world—a tiny speck of brick color turns out to be a moth. The world within one's purview is suddenly revealed to belong to another. She quotes Simone Weil and Iris Murdoch on 'de-centering': that beauty begins with a kind of ego displacement, a sudden dispossession. This of course is where collage and the found image begin,

Demand the Impossible a

with the image out of control like the dream image. Beauty in Scarry's terms is a sudden awareness of otherness within the familiar unfolding of space in time. Scarry describes this as a kind of fullness and aliveness. I prefer to think of this as a sense of absence and death.

Michael Bracewell: Could you outline what you feel have been recent developments or breakthroughs in your work? Nuances of thinking, or new ideas?

John Stezaker: Much of the work in the past couple of years has centered on the face. A recent acquisition of a collection of portraits of film actors and actresses, which seemingly derived originally from an agency's archive, has given me material for a new series of collages which explore the relationship between the experiences of the face and of cinema. I am working on the idea of the 'close-up.' As to breakthroughs, I am satisfied with the little 'tear' here and there, to use Scarry's metaphor.

©John Foley-Odale

Michael Bracewell is a regular contributor to frieze magazine and the author of six novels. His non-fiction includes *England Is Mine: Pop Life in Albion from Wilde to Goldie* (HarperCollins Publishers Ltd., 1997), *The Nineties: When Surface was Depth* (Flamingo, 2002), and *Roxyism* (Flamingo, 2005). He has written essays for several exhibition catalogues and is the editor of *The World of Gilbert & George* (D.A.P./Distributed Art Publishers, 2007). Bracewell lives and works in London, England.

A shorter version of this interview originally appeared in frieze, Issue 89, March 2005.

More

Plates of Works

Blind, 1979
Collage
Image size: 7 5/8 x 9 1/2 in. (19.4 x 24.1 cm)
Paper size: 7 7/8 x 9 7/8 in. (20 x 25.1 cm)
JS1
pp 44-47

The Trial, 1980
Collage
Image size: 7 5/8 x 9 5/8 in. (19.4 x 24.5 cm)
Paper size: 7 3/4 x 9 3/4 in. (19.7 x 24.8 cm)
JS2
pp 48-51

Tabula Rasa II, 1983
Collage
Image size: 5 7/8 x 7 3/4 in. (14.9 x 19.7 cm)
Paper size: 6 1/8 x 8 1/16 in. (15.6 x 20.5 cm)
JS3
pp 52-55

Mask II, 1991-1992
Collage
Image size: 10 x 7 7/8 in. (25.4 x 20 cm)
Paper size: 10 3/4 x 8 3/8 in. (27.3 x 21.3 cm)
JS4
pp 56-59

Mask IV, 2005
Collage
Image size: 8 1/8 x 6 1/2 in. (20.6 x 16.5 cm)
Paper size: 9 1/2 x 7 1/4 in. (24.1 x 18.4 cm)
JS5
pp 60-63

Mask V, 2005
Collage
Image size: 9 3/8 x 7 in. (23.8 x 17.8 cm)
Paper size: 10 x 8 1/8 in. (25.4 x 20.6 cm)
JS6
pp 64-67

Mask VII, 2005
Collage
Image size: 8 1/4 x 6 7/8 in. (20.9 x 17.5 cm)
Paper size: 9 1/2 x 7 1/4 in. (24.1 x 18.4 cm)
JS7
pp 68-71

Mask VIII, 2005
Collage
Image size: 9 1/2 x 7 3/4 in. (24 x 19.7 cm)
Paper size: 10 5/8 x 7 7/8 in. (26.7 x 20 cm)
JS8
pp 72-75

Film Portrait (Landscape) VIII, 2005
Collage
Image size: 9 3/4 x 7 3/4 in. (24.8 x 19.7 cm)
Paper size: 13 5/8 x 10 3/8 in. (34.6 x 26.4 cm)
JS9
pp 76-79

Film Portrait (Landscape) XI, 2005
Collage
Image size: 9 5/8 x 7 3/4 in. (24.5 x 19.7 cm)
Paper size: 13 x 9 1/2 in. (33 x 24.1 cm)
JS10
pp 80-83

Film Portrait (Incision) III, 2005
Collage
Image size: 7 3/4 x 7 1/8 in. (19.7 x 18.1 cm)
Paper size: 13 1/4 x 10 1/8 in. (33.7 x 25.7 cm)
JS11
pp 84-87

Film Portrait (Incision) VI, 2005
Collage
Image size: 9 1/4 x 7 5/8 in. (23.5 x 19.4 cm)
Paper size: 11 1/8 x 10 1/8 in. (28.3 x 25.7 cm)
JS12
pp 88-91

Film Portrait (She) V, 2005
Collage
Image size: 8 x 7 3/4 in. (20.3 x 19.7 cm)
Paper size: 11 3/8 x 8 5/8 in. (28.9 x 21.9 cm)
JS13
pp 92-95

Cinema 2 I, 2005
Collage
Image size: 7 7/8 x 11 5/8 in. (20 x 29.5 cm)
Paper size: 9 1/2 x 13 in. (24.1 x 33 cm)
JS14
pp 96-99

Cinema 2 II, 2005
Collage
Image size: 7 1/2 x 11 7/8 in. (19.1 x 30.2 cm)
Paper size: 9 1/2 x 13 in. (24.1 x 33 cm)
JS15
pp 100-103

Untitled, 2007
Collage
10 1/4 x 7 7/8 in. (26 x 20 cm)
JS16
pp 104-107

Untitled, 2007
Collage
11 1/4 x 8 in. (28.6 x 20.3 cm)
JS17
pp 108-111

Blind

1979
Collage
Image size: 7 5/8 x 9 1/2 in. (19.4 x 24.1 cm)
Paper size: 7 7/8 x 9 7/8 in. (20 x 25.1 cm)
JS1

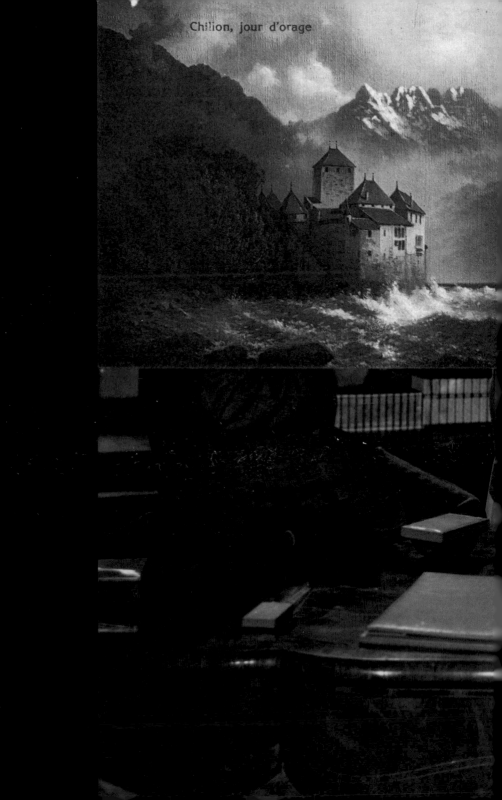

Chilion, jour d'orage

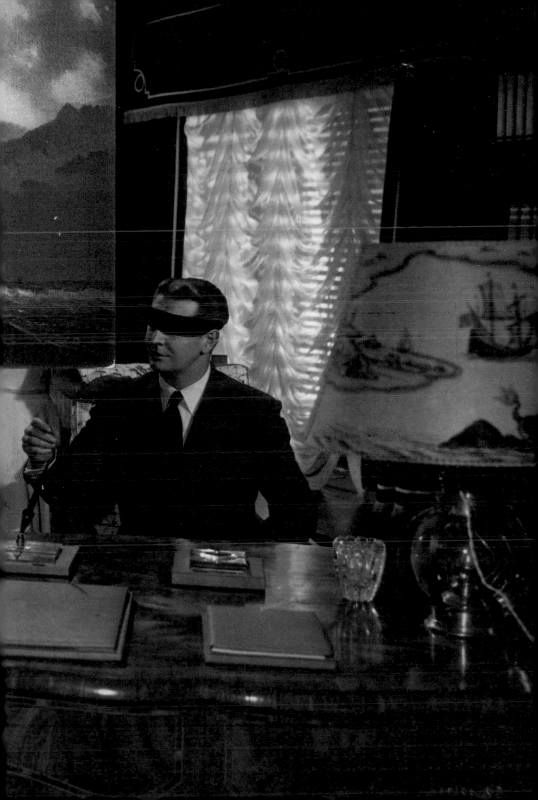

The Trial

1980
Collage
Image size: 7 5/8 x 9 5/8 in. (19.4 x 24.5 cm)
Paper size: 7 3/4 x 9 3/4 in. (19.7 x 24.8 cm)
JS2

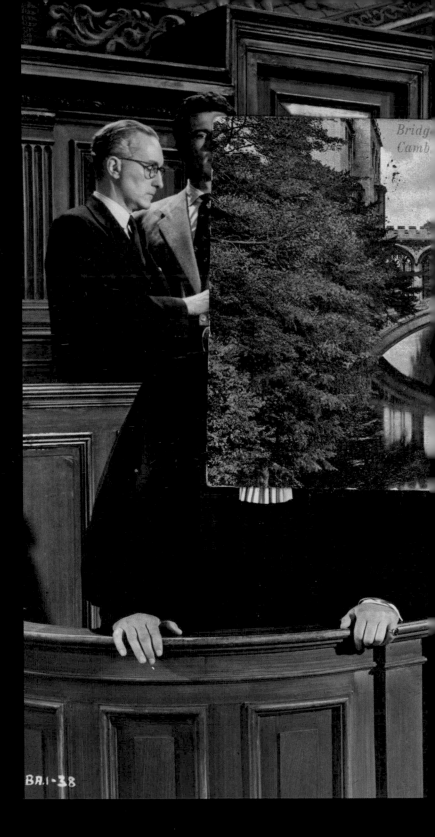

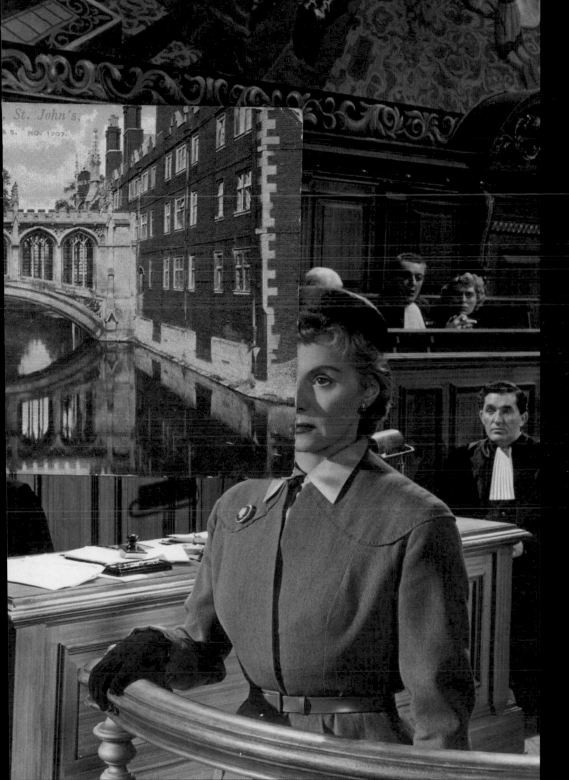

Tabula Rasa II

1983
Collage
Image size: 5 7/8 x 7 3/4 in. (14.9 x 19.7 cm)
Paper size: 6 1/8 x 8 1/16 in. (15.6 x 20.5 cm)
JS3

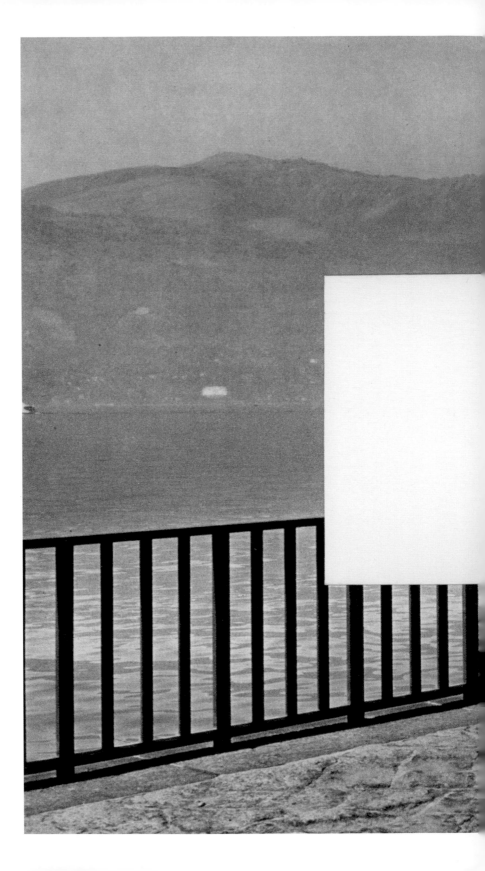

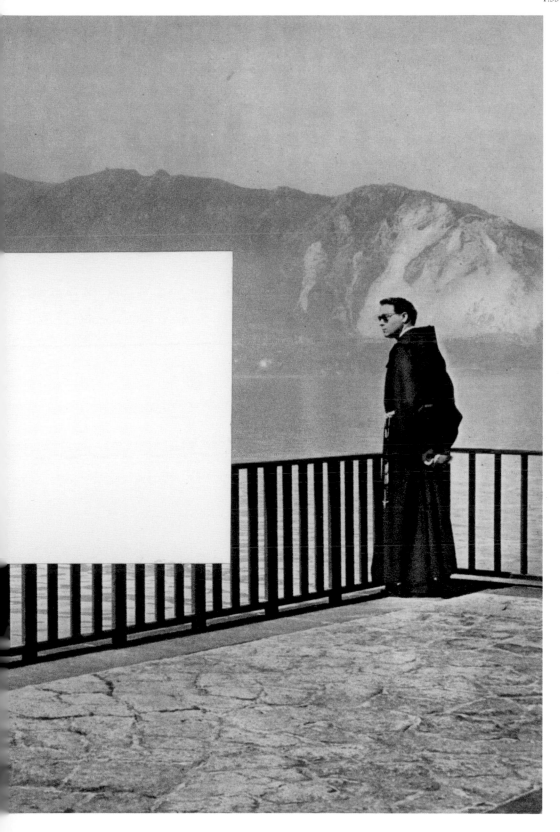

Mask II

1991-1992
Collage
Image size: 10 x 7 7/8 in. (25.4 x 20 cm)
Paper size: 10 3/4 x 8 3/8 in. (27.3 x 21.3 cm)
JS4

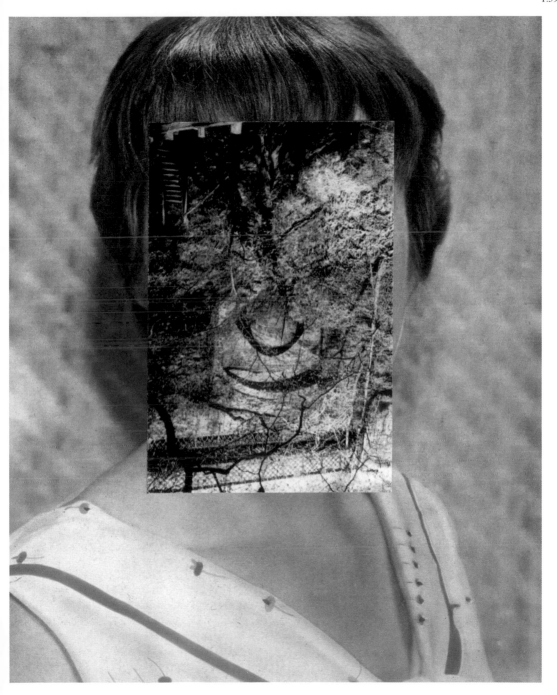

Mask IV

2005
Collage
Image size: 8 1/8 x 6 1/2 in. (20.6 x 16.5 cm)
Paper size: 9 1/2 x 7 1/4 in. (24.1 x 18.4 cm)
JS5

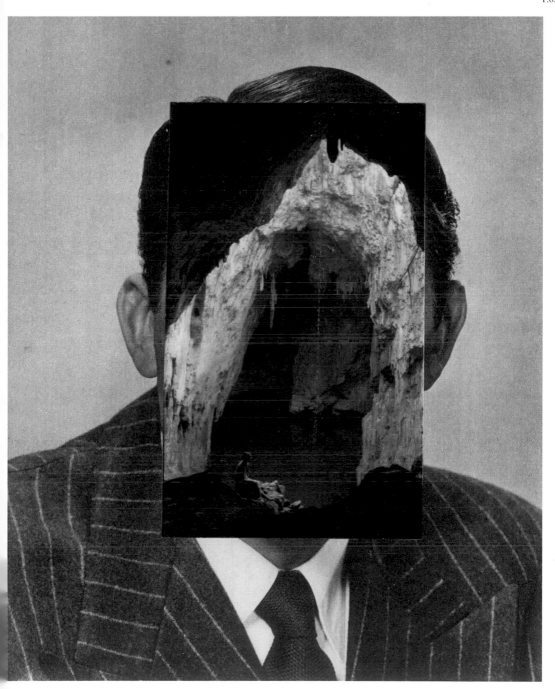

Mask V

2005
Collage
Image size: 9 3/8 x 7 in. (23.8 x 17.8 cm)
Paper size: 10 x 8 1/8 in. (25.4 x 20.6 cm)
JS6

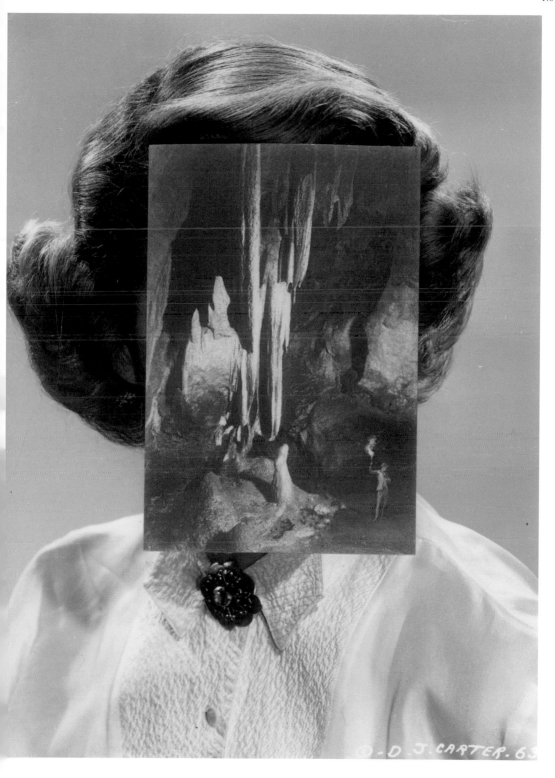

© D. J. CARTER. 65

Mask VII

2005
Collage
Image size: 8 1/4 x 6 7/8 in. (20.9 x 17.5 cm)
Paper size: 9 1/2 x 7 1/4 in. (24.1 x 18.4 cm)
JS7

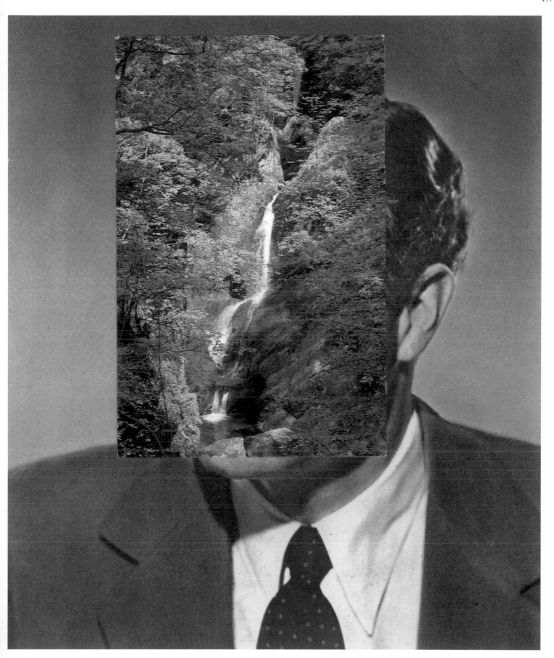

Mask VIII

2005
Collage
Image size: 9 1/2 x 7 3/4 in. (24 x 19.7 cm)
Paper size: 10 5/8 x 7 7/8 in. (26.7 x 20 cm)
JS8

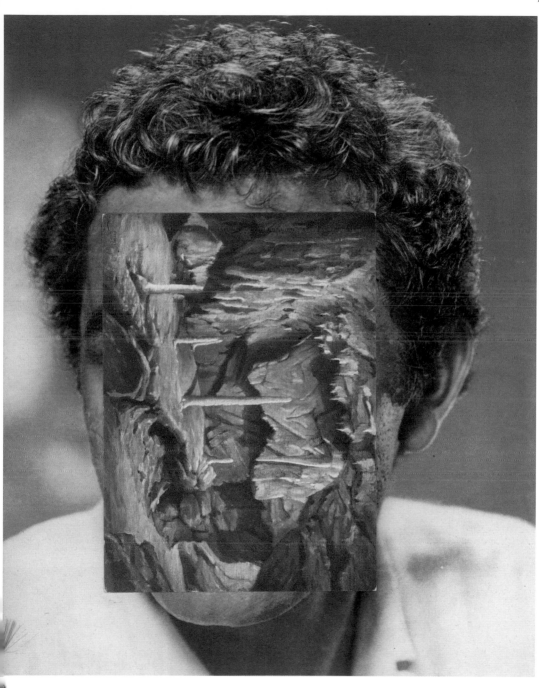

Film Portrait (Landscape) VIII

2005
Collage
Image size: 9 3/4 x 7 3/4 in. (24.8 x 19.7 cm)
Paper size: 13 5/8 x 10 3/8 in. (34.6 x 26.4 cm)
JS9

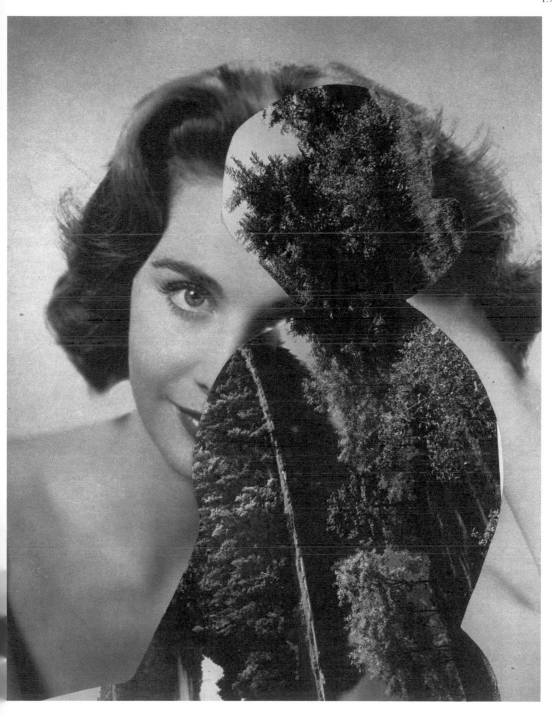

Film Portrait (Landscape) XI

2005
Collage
Image size: 9 5/8 x 7 3/4 in. (24.5 x 19.7 cm)
Paper size: 13 x 9 1/2 in. (33 x 24.1 cm)
JS10

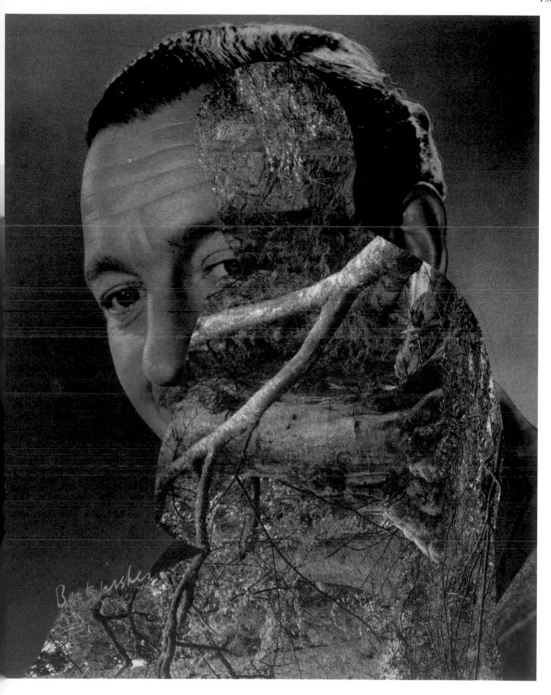

Film Portrait (Incision) III

2005
Collage
Image size: 7 3/4 x 7 1/8 in. (19.7 x 18.1 cm)
Paper size: 13 1/4 x 10 1/8 in. (33.7 x 25.7 cm)
JS11

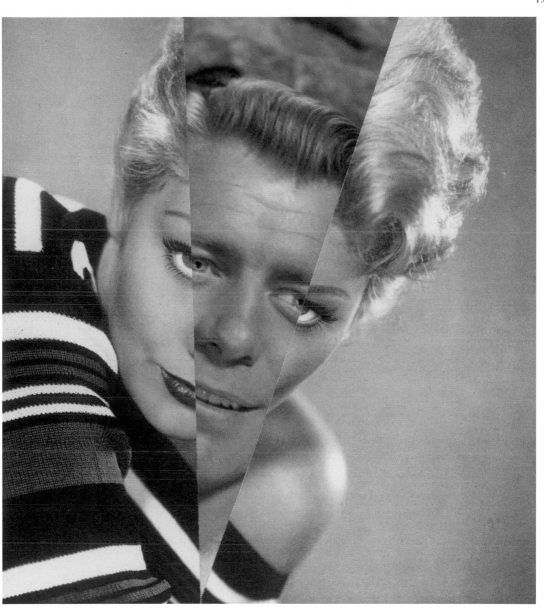

Film Portrait (Incision) VI

2005
Collage
Image size: 9 1/4 x 7 5/8 in. (23.5 x 19.4 cm)
Paper size: 11 1/8 x 10 1/8 in. (28.3 x 25.7 cm)
JS12

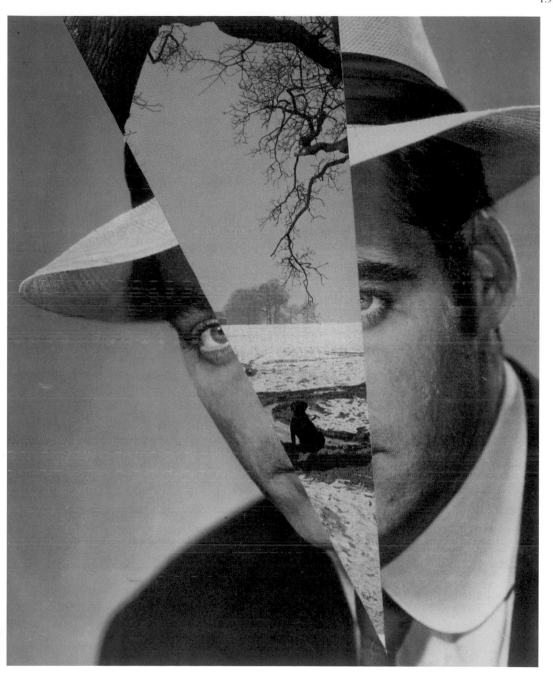

Film Portrait (She) V

2005
Collage
Image size: 8 x 7 3/4 in. (20.3 x 19.7 cm)
Paper size: 11 3/8 x 8 5/8 in. (28.9 x 21.9 cm)
JS13

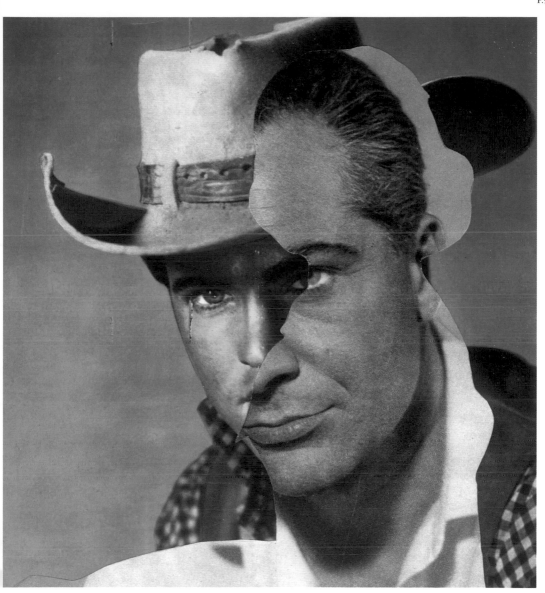

Cinema 2 I

2005
Collage
Image size: 7 7/8 x 11 5/8 in. (20 x 29.5 cm)
Paper size: 9 1/2 x 13 in. (24.1 x 33 cm)
JS14

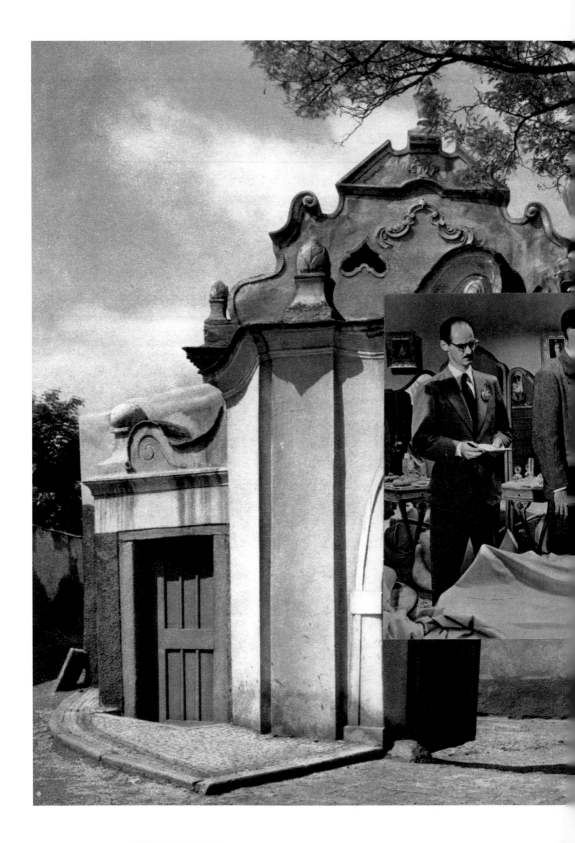

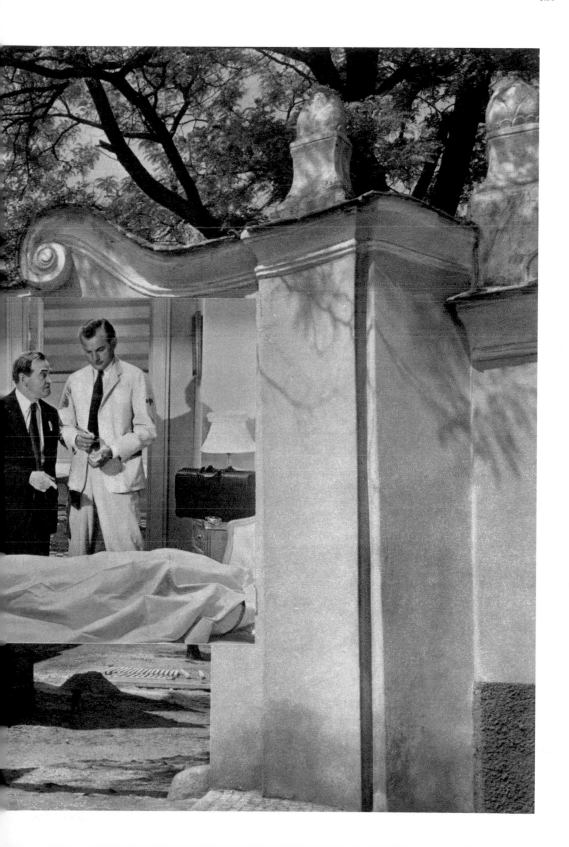

Cinema 2 II

2005
Collage
Image size: 7 1/2 x 11 7/8 in. (19.1 x 30.2 cm)
Paper size: 9 1/2 x 13 in. (24.1 x 33 cm)
JS15

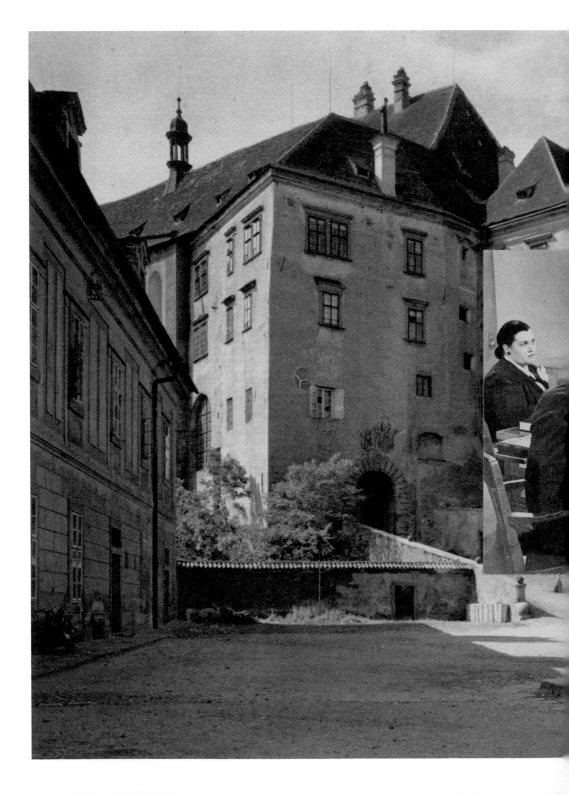

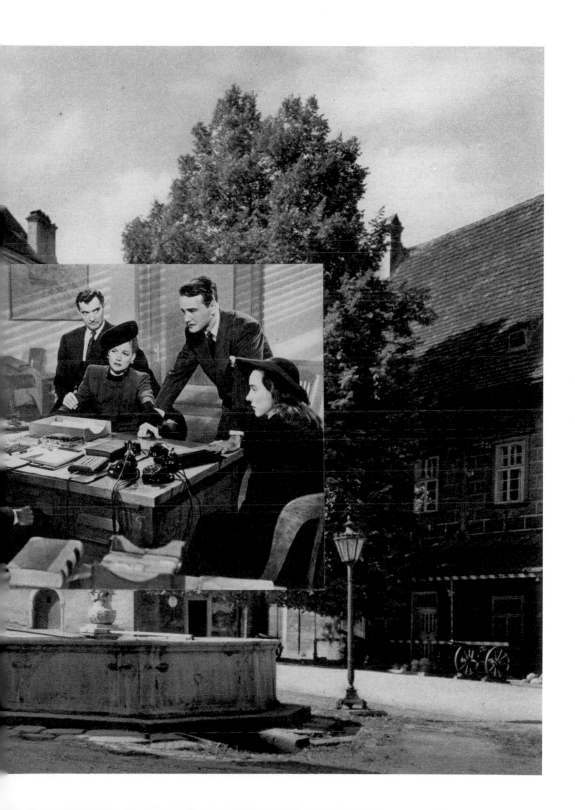

Untitled

2007
Collage
10 1/4 x 7 7/8 in. (26 x 20 cm)
JS16

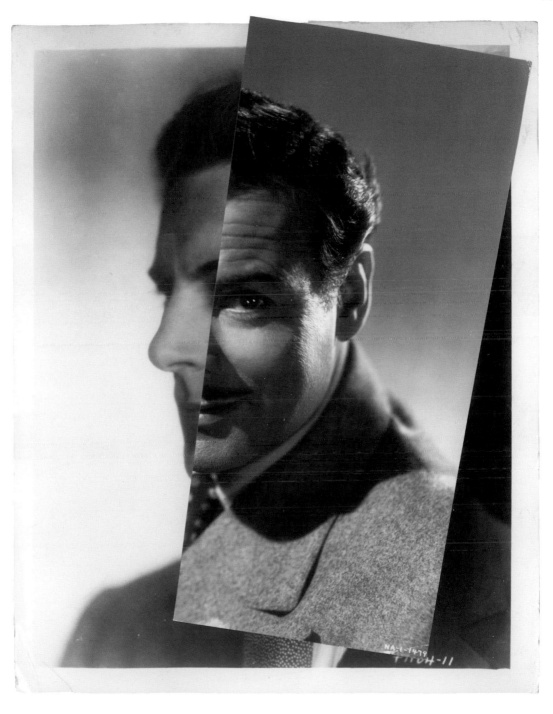

Untitled

2007
Collage
11 1/4 x 8 in. (28.6 x 20.3 cm)
JS17

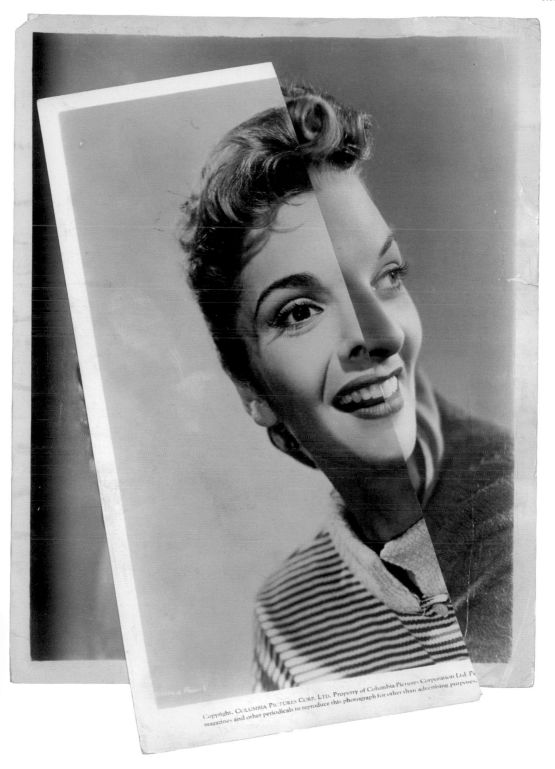

Installation Views: RFC

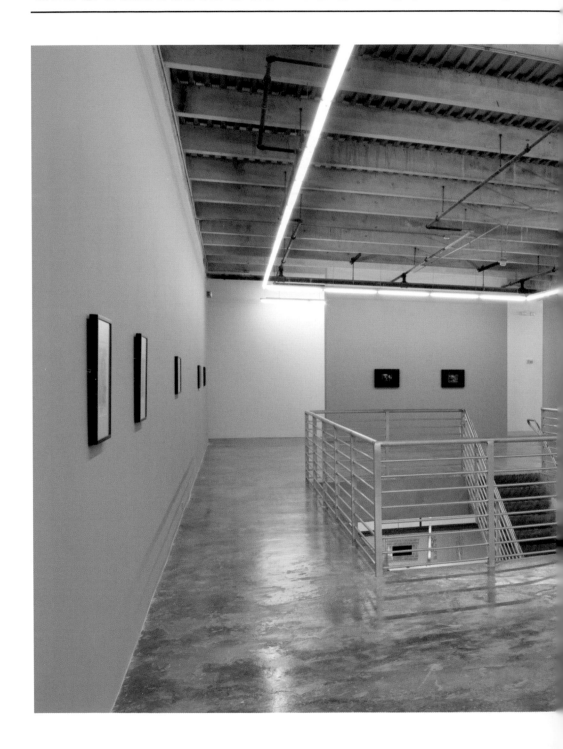

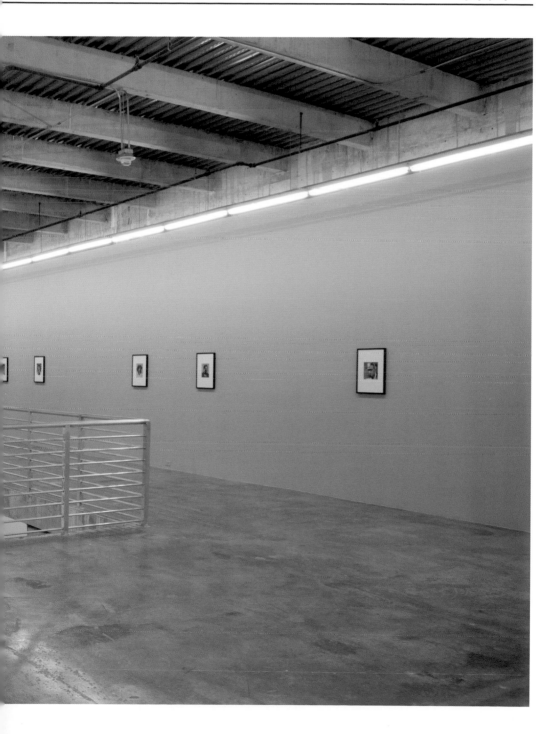

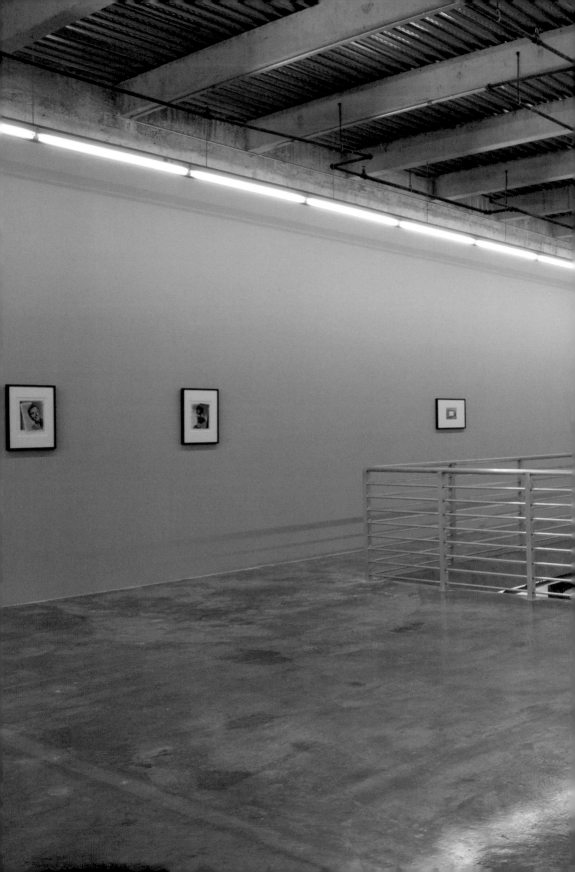

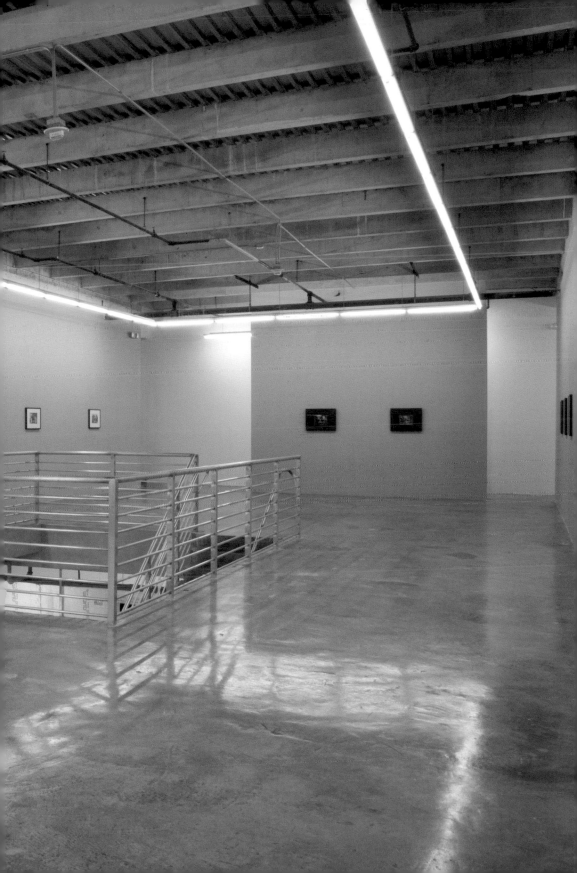

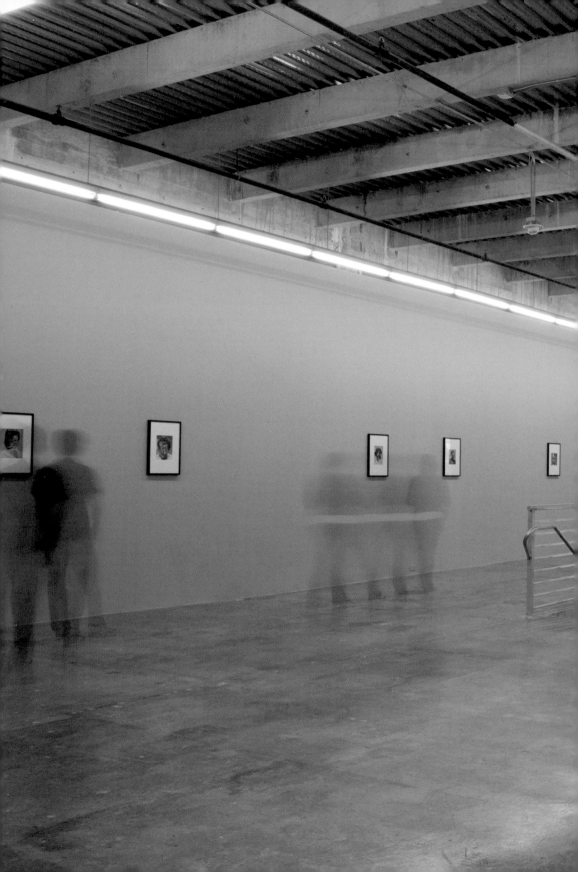

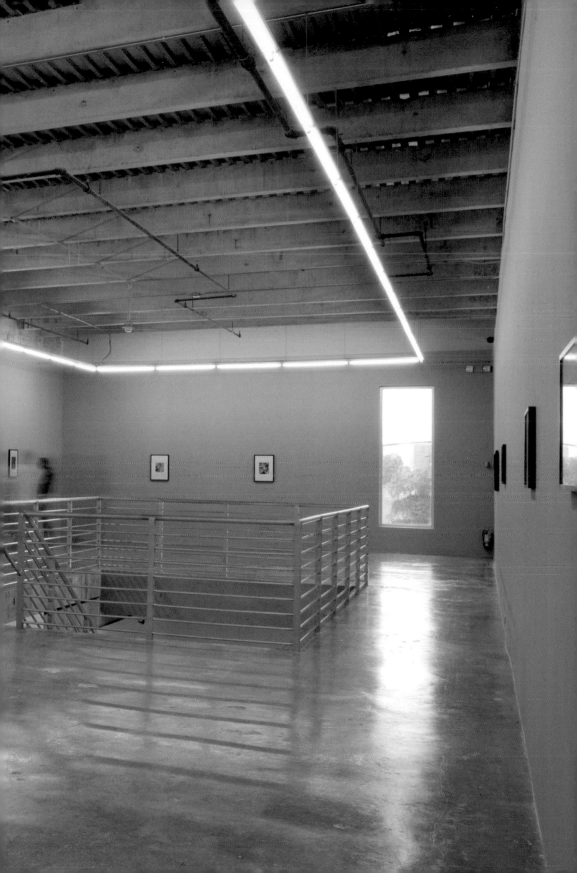

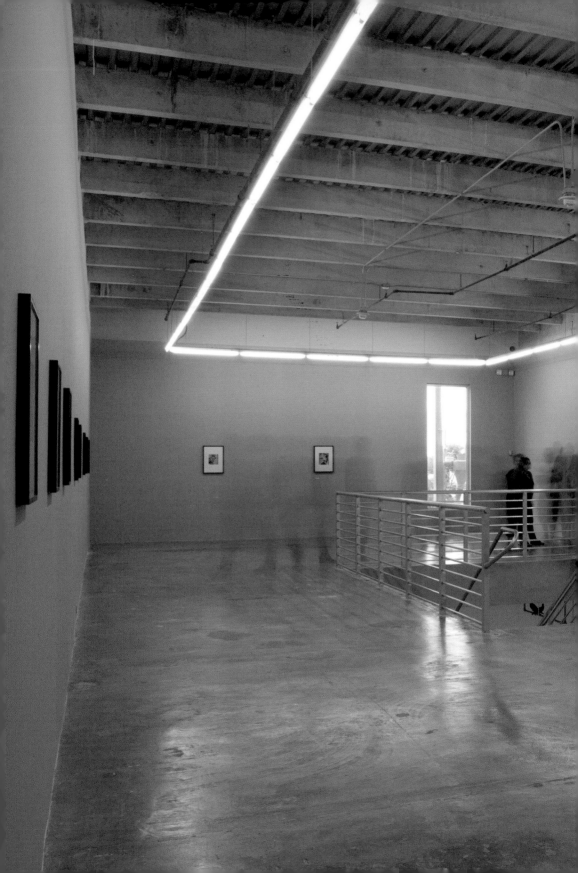

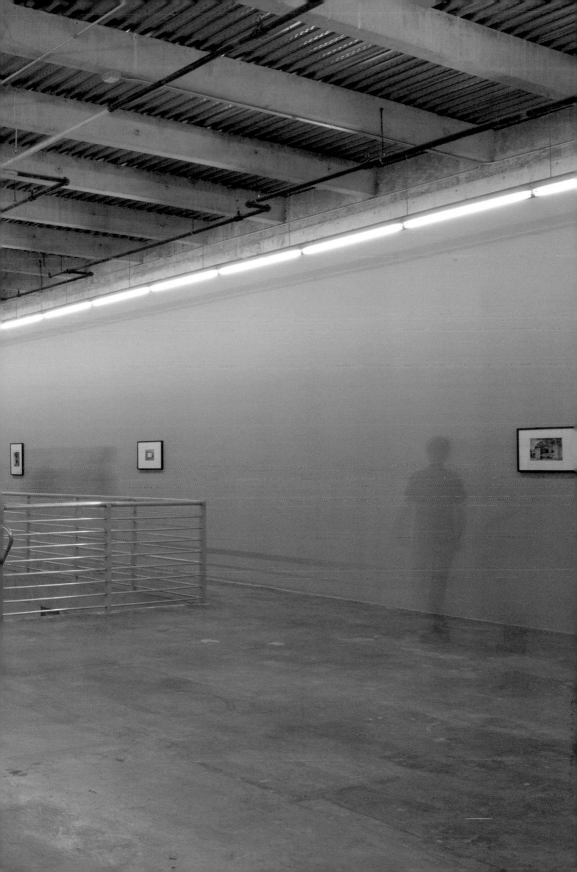

Biography

John Stezaker

Born in Worcester, England, 1949
Lives and works in London, England

Education

1973 B.F.A., The Slade School of Art, London, England

Selected Solo Exhibitions

2007 *John Stezaker: Works from the Rubell Family Collection*, Rubell Family Collection, Miami, FL [cat.]
 John Stezaker, Karsten Schubert, London, England, and The Approach, London, England
 John Stezaker, Stills Gallery, Edinburgh, Scotland
 John Stezaker, Project Room, Galerie Yvon Lambert, Paris, France
2006 *John Stezaker,* The Approach, London, England
 John Stezaker New Works, Galerie Dennis Kimmerich, Dusseldorf, Germany
 John Stezaker, Richard Telles Fine Art, Los Angeles, CA
 John Stezaker—Bridges and other Metaphors, Norwich Gallery, Norwich School of Art and Design,
 Norwich, England [cat.]
 John Stezaker, White Room, White Columns, New York, NY
2005 *Archiv & Erzählung [Archives and Narration]: John Stezaker and T.J. Wilcox,* Kunstverein München,
 Munich, Germany
2004 *The Third Person Archive and Other Works,* The Approach, London, England
2001 *Holy Land Series,* Wigmore Fine Arts, London, England
1999 *Angels,* Portfolio Gallery, Edinburgh, Scotland
1996 *John Stezaker—Garden*, CUBITT Gallery and Studios, London, England
1991 *John Stezaker—Care & Control,* Salama-Caro Gallery, London, England
1990 *Film Still Collages,* Friedman-Guinness Gallery, Frankfurt, Germany [cat.]
1989 *John Stezaker: New Work*, Salama-Caro Gallery, London, England [cat.]
 Glenn Dash Gallery, Los Angeles, CA
1984 Lisson Gallery, London, England
1979 Galerie Éric Fabre, Paris, France
 John Stezaker: Werke 1973-1978 [Works 1973-1978], Kunstmuseum Luzern, Lucerne,
 Switzerland [cat.]
 Ikon Gallery, Birmingham, England
 John Stezaker: The World Made Flesh, New 57 Gallery, Edinburgh, Scotland [cat.]
1978 *John Stezaker: Fragments,* The Photographers' Gallery, London, England [cat.]
 Collages, 1977-1978, Ikon Gallery, Birmingham, England [cat.]
 Southampton City Art Gallery, Southampton, England
1977 *Dream Allegories. John Stezaker Collages 1976-1977,* Nigel Greenwood Gallery, London,
 England [cat.]
 Galerie Éric Fabre, Paris, France
 Schema Gallery, Florence, Italy
 Spectro Arts Workshop, Newcastle, England
1976 Nigel Greenwood Gallery, London, England
 John Stezaker: Trois Oeuvres [Three Works], Galerie Éric Fabre, Paris, France [cat.]

1975 Nigel Greenwood Gallery, London, England
 Galerie Éric Fabre, Paris, France
1974 Galerie December, Munster, Germany
 Galleria Lia Rumma, Rome, Italy
 Galleria Lia Rumma, Naples, Italy
1973 Modern Art Oxford, Oxford, England
1972 *John Stezaker: Beyond "Art for Art's Sake": a Propus Mundus,* Nigel Greenwood Gallery, London, England [cat.]
1971 *John Stezaker: Works, 1969-1971,* Sigi Krauss Gallery, London, England [cat.]

Selected Group Exhibitions

2007 *Panic Attack! Art in the Punk Years,* Barbican Art Gallery, London, England
2006 *Dereconstruction,* Gladstone Gallery, New York, NY
 A Season In Hell: Nicky Coutts, Rachel Reupke, Hiraki Sawa, John Stezaker, Danielle Arnaud contemporary art, London, England
 World Gone Mad: Surrealist Returns in Recent British Art, Herbert Read Gallery, Canterbury; traveled to Castlefield Gallery, Manchester; Limehouse Arts Foundation, London, England [cat.]
 The Glass Bead Game, Berlin Project Space, Vilma Gold, Berlin, Germany
 Tate Triennial 2006: New British Art, Tate Britain, London, England [cat.]
2005 *Time Lines,* Kunstverein für die Rheinlande und Westfalen, Dusseldorf, Germany
 1979, Bloomberg SPACE, London, England
 Cut, The Approach, London, England
 Girls on Film, Zwirner & Wirth, New York, NY
 COLLAGE: signs & surfaces, Pavel Zoubok Gallery, New York, NY [cat.]
 Mourning, Sies + Höke Galerie, Dusseldorf, Germany
 RCA print folio, Royal College of Art, London, England
2004 *Collage,* Bloomberg SPACE, London, England
 Je t'envisage. La disparition du portrait, Musée de l'Elysée, Lausanne, Switzerland
 Cara a Cara, Culturgest, Lisbon, Portugal
 About Face: Photography and the Death of the Portrait, The Hayward Gallery, London, England
 Future Face, Science Museum, London, England
 Portraits of Non-Humans, David Risley Gallery, London, England
 Polaroid, 39, London, England
2003 *Ex-Press,* Royal College of Art, London, England
 Please Take One, 39, London, England
2002 *Life is Beautiful,* Laing Art Gallery, Newcastle, England [cat.]
2000 *The British Art Show 5,* shown simultaneously at: City Art Centre, Collective Gallery, Dean Gallery, Fruitmarket Gallery, Royal Botanic Garden Edinburgh, Scottish National Gallery of Modern Art, Stills Gallery, Talbot Rice Gallery, Edinburgh, Scotland; John Hansard Gallery, Millais Gallery, Southampton Institute, Southampton City Art Gallery, Southampton, England; Centre for Visual Arts, Chapter Arts Centre, Fotogallery, National Museum & Gallery, Cardiff, Wales; Birmingham Museum and Art Gallery, Ikon Gallery, Birmingham, England [cat.]
1999 23rd Ljubljana International Biennial of Graphic Art, British Section, Mednarodni grafični likovni center [International Centre of Graphic Arts], Ljubljana, Slovenia
 River Deep, Mountain High, Gallery Westland Place, London, England; traveled to University of Dundee, Duncan of Jordanstone College of Art and Design, Dundee, Scotland
1998 *American and European Photo-art,* Larem Kloker Gallery, Vienna, Austria

Biography

2nd Shoreditch Photography Biennial, London, England

Chemical Traces / Photography and Conceptual Art, 1968-1998, Ferens Art Gallery, Hull City Council, Kingston upon Hull, England; traveled to Leeds City Art Gallery, Leeds, England [cat.]

1997 *Pictura Britannica: Art from Britain,* British Council, Museum of Contemporary Art, Sydney, Australia; traveled to Art Gallery of South Australia, Adelaide, Australia; Museum of New Zealand Te Papa Tongarewa, Wellington, New Zealand [cat.]

Strange Days: British Contemporary Photography, Claudia Gian Ferrari Arte Contemporanea, Milan, Italy [cat.]

Sad, Gasworks, London, England

The Quick and the Dead, Royal College of Art, London, England

The Impossible Document: Photography and Conceptual Art in Britain 1966-1976, Camerawork Gallery, London, England; traveled to Cambridge Darkroom Gallery, Cambridge, England [cat.]

Life / Live: Young British Art, Musée d'Art Moderne de la Ville de Paris, Paris, France; traveled to Centro Cultural de Belém, Lisbon, Portugal [cat.]

1995 *Elvis + Marilyn: 2 x Immortal,* The Institute of Contemporary Art, Boston, MA; traveled to Contemporary Arts Museum Houston, Houston, TX; Mint Museum of Art, Charlotte, NC; The Cleveland Museum of Art, Cleveland, OH; Museum of Contemporary Art Jacksonville, Jacksonville, FL; Portland Art Museum, Portland, OR; Philbrook Academy, Tulsa, OK; The Columbus Museum of Art, Columbus, OH; The Tennessee State Museum, Nashville, TN; The San Jose Museum of Art, San Jose, CA; The Honolulu Academy of Arts, Honolulu, HI; Hokkaido Obihiro Museum of Art, Hokkaido, Japan; Daimaru Museum, Umeda-Osaka, Japan; Takamatsu City Museum of Art, Takamatsu, Japan; Sogo Museum of Art, Yokohama, Japan; Mitsukoshi Museum of Art, Fukuoka, Japan

The Curator's Egg, Anthony Reynolds Gallery, London, England

1994 *Who's Looking at the Family?,* Barbican Art Gallery, London, England

1992 *Flora Photographica,* Serpentine Gallery, London, England

1990 *Art Conceptuel, Formes Conceptuelles,* Galerie 1900 / 2000, Paris, France

1989 *John Stezaker,* Glenn Dash Gallery, Los Angeles, CA

1988 *Altered States,* Kent Gallery, New York, NY [cat.]

Multiple vision: Ron Haselden, Colin McArthur, John Stezaker, Paul Wombell, Cambridge Darkroom Gallery, Cambridge, England

1984 *1984: An Exhibition.* Camden Arts Centre, London, England [cat.]

1983 *Geometry of Desire,* Galerie 't Venster, Rotterdam, Netherlands

1982 *Simulacra,* Riverside Studios, London, England

Aperto '82, XL Biennale di Venezia, Venice, Italy [cat.]

Close to the Edge, White Columns, New York, NY

1979 *Hayward Annual,* The Hayward Gallery, London, England [cat.]

Un Certain Art Anglais, Musée d'Art Moderne de la Ville de Paris, Paris, France

JP2 Art Actuel en Belgique et en Grande-Bretagne, Palais des Beaux-Arts, Bruxelles, Brussels, Belgium

1978 *Art for Society,* Whitechapel Art Gallery, London, England

1977 *British Art,* Palais des Beaux-Arts, Bruxelles, Brussels, Belgium

1976 *Arte Inglese Oggi,* Palazzo Reale, Milan, Italy

Times, Words and the Camera, Akademische Druck-u, Graz, Austria

1975 *IX Biennale de Paris,* Paris, France

1974 *Projekt '74,* Kunsthalle Köln, Cologne, Germany

Critic's Choice, Tooths Gallery, London, England

Beyond Painting & Sculpture: Works bought for the Arts Council by Richard Cork, Leeds City Art Gallery, Leeds, England; traveled to Walker Art Gallery, Liverpool, England; Arnolfini Gallery, Bristol, England

1972 *A Survey of the Avant-Garde in Britain*, Gallery House, London, England
 The New Art, The Hayward Gallery, London, England [cat.]
1971 *The Wall Show*, Lisson Gallery, London, England
1970 *Three Schools Exhibition*, Royal Academy of Arts, London, England
1969 *Three Person Show*, University College London, London, England

Selected Solo Exhibition Catalogues/Artist's Books

Brooks, Rosetta and Martin Kunz. *John Stezaker: Werke 1973-1978 [Works 1973 1978]*. Lucerne:
 Kunstmuseum Luzern, 1979.
Coetzee, Mark. *John Stezaker: Works from the Rubell Family Collection*. Miami:
 Rubell Family Collection, 2007.
Collages, 1977-78. Birmingham: Ikon Gallery, 1978.
Dream Allegories. John Stezaker Collages 1976-1977. London: Nigel Greenwood Gallery, 1977.
Fijałkowski, Krzysztof. *John Stezaker—Bridges and other Metaphors*. Norwich: Norwich School of Art and
 Design, 2007.
John Stezaker: Beyond "Art for Art's Sake": a Propus Mundus. London: Nigel Greenwood Gallery, 1973.
John Stezaker: Fragments. London: The Photographers' Gallery, 1978.
John Stezaker: New Work. London: Salama-Caro Gallery, 1989.
John Stezaker: Trois Oeuvres [Three Works]. Paris: Galerie Éric Fabre, 1975.
John Stezaker: The World Made Flesh. Edinburgh: New 57 Gallery, 1979.
John Stezaker: Works, 1969-1971. London: Sigi Krauss Gallery, 1971.
Mellor, David. *John Stezaker: Film Still Collages*. Frankfurt: Friedman-Guinness Gallery, 1990.
Miles, Jonathan. *John Stezaker*. Frankfurt: Friedman-Guinness Gallery, 1989.
Stezaker, John. *Metaphor in Art and Architecture*. Publisher: [s.n.], 1975.

Selected Group Exhibition Catalogues/Publications

Beyond Painting & Sculpture: Works bought for the Arts Council by Richard Cork. London: Arts Council of
 Great Britain, 1973.
Bickers, Patricia, Stephen Snoddy and Bernice Murphy. *Pictura Britannica: Art from Britain*. Sydney:
 Museum of Contemporary Art, 1997.
Brooks, Rosetta. *Altered States*. New York: Kent Gallery; New York: ZG Publications, 1988.
Büchler, Pavel and Nikos Papastergiadis, eds. *Random Access: on crisis and its metaphors*. London: Rivers
 Oram Press; Concord: Paul and Company, 1995.
Campbell, Robin and Anne Seymour. *The New Art. The Hayward Gallery*. London: Arts Council of Great
 Britain, 1972.
Collage: signs & surfaces. New York: Pavel Zoubok Gallery, 2005.
Fuchs, Rudolf Herman. *Languages: an exhibition of artists using word and image*. London: Arts Council of
 Great Britain, 1979.
Higgs, Matthew, Pippa Coles and Jacqui Poncelet. *The British Art Show 5*. London: Hayward Gallery
 Publishing, 2000.
Lampert, Catherine, William Furlong, Terrence Maloon, et al. *Hayward Annual 1979*. London: Hayward
 Gallery Publishing, 1979.
Mellor, Alan. *Chemical Traces: Photography and Conceptual Art, 1968-1998*. Kingston upon Hull: Ferens Art
 Gallery, 1998.
Obrist, Hans-Ulrich, ed. *Life / Live: Young British Art*. Paris: Musée d'Art Moderne
 de la Ville de Paris, 1997.

Biography

O'Reilly, Sally, Johanna Malt and J.J. Charlesworth. *World Gone Mad: Surrealist Returns in Recent British Art*. London: Castlefield Gallery Publications, 2006.

Petherbridge, D. and J. Richardson. *1984: An Exhibition*. London: Camden Arts Centre, 1984.

Reichardt, Jasia. *Time, Words and the Camera*. Graz: Akademische Druck-u Verlagsanstalt, 1976.

Roberts, John, ed. *The Impossible Document: Photography and Conceptual Art in Britain, 1966-1976*. London: Camerawork, 1997.

Williams, Gilda. *Strange Days: British Contemporary Photography*. Milan: Charta, 1997.

Selected Surveys and Collection Catalogues

Campany, David. *Art and Photography*. London and New York: Phaidon Press, 2003.

DePaoli, Geri and Wendy McDaris. *Elvis + Marilyn: 2 x Immortal*. New York: Rizzoli, 1994.

Ewing, William A. *The Body: Photographs of the Human Form*. San Francisco: Chronicle Books, 1994.

Green, David and Joanna Lowry, eds. *Stillness and Time: Photography and the Moving Image*. Brighton: Photoworks, 2006.

Patrizio, Andrew. *Two Nine Two: Essays in Visual Culture*. Edinburgh: Faculty of Art & Design, Edinburgh College of Art, 2000.

Roberts, John. *The Art of Interruption—Realism, Photography and the Everyday*. Manchester and New York: Manchester University Press, 1998.

Alonso, Rodrigo and T.J. Demos. *Vitamin Ph: New Perspectives in Photography*. London: Phaidon, 2006.

Steyne, Juliet, ed. *Pretext: Heteronyms*. London: Rear Window Publications, 1995.

Taylor, Brandon. *Collage: The Making of Modern Art*. London: Thames & Hudson, 2004.

Walker, John A. *Art in the Age of Mass Media*. Boulder: Westview Press, 1994.

Williams, Val, editor. *Who's Looking at the Family?* London: Barbican Art Gallery, 1994.

Selected Interviews, Articles and Reviews

"Angels." Coil [No. 5, 1997]: 1-2.

Barro, David. "Live in Your Head." Lapiz [Vol. 20, No. 171, 2001]: 76.

Blakeston, O. "Exhibitions Reviews." Arts Review [Vol. 29, No. 12, 1977]: 398-399.

Blakeston, O. "John Stezaker, Nigel Greenwood, London." Arts Review [Vol. 30, No. 14, 1973]: 388.

Bowen, D. "John Stezaker, Nigel Greenwood, London." Arts Review [Vol. 25, No. 22, 1973]: 753.

Bracewell, Michael. "Demand the Impossible." frieze [No. 89, 2005]: 88-93.

Brisley, S. and John Stezaker. "Polemics." Art Monthly [No. 62, Dec. 1982 - Jan. 1983]: 29-31.

Brooks, R. "A Survey of the Avant-Garde in Britain." Flash Art [No. 39, Feb. 1973]: 6-7.

Brooks, R. "An Art of Controlled Madness." Art And Text [No.17, 1985]: 22-27.

Brooks, R. "Please, No Slogans." Studio International [Vol. 191, No. 980, 1976]: 155-161.

Brooks, R. "Problem Solving and Question Begging: The Works of Art-Language and John Stezaker." Studio International [Vol. 186, No. 961, Dec. 1973]: 276-278.

Campany, David. "Recent Work: John Stezaker." Photoworks [No. 8, May 2007]: 12-19.

Dannatt, Adrian. "John Stezaker." Flash Art [Vol. 24, No. 160, Oct. 1991]: 114-117.

De Benito, Eduardo. "Londres: Entre Aquí y La Nada." Lapiz [Vol. 1, No. 2, Jan. 1983]: 50-53.

Falconer, Morgan. "Contemporary Art." The Burlington Magazine [Vol. 147, No. 1223, Feb. 2005]: 130-132.

Hall, Charles. "Now Voyager." Art Review [Vol. 45, Sept. 1993]: 48-49.

Hatton, Brian. "Paraphotography." Art Monthly [No. 207, June 1997]: 1-5.

Hatton, Brian. "Simulacra at the Riverside." Artscribe [No. 39, Feb. 1983]: 30-34.

Hunt, Ian. "British Art Show 5." Art Monthly [No. 236, May 2000]: 30-33.

"John Stezaker." Flash Art [No. 66-67, 1976]: 23.

Marsh, Andrew. "Reviews: John Stezaker." Flash Art [Vol. 40, No. 252, Feb. 2007]: 119.

Mellor, David Alan. "Fearful Symmetry: John Stezaker." Portfolio Catalogue [No. 29, June 1999]: 34-39, 58-59.

Morris, L. "English Art Today." Data [No. 20, March - April 1976]: 45-46, 53-59.

Newman, Michael. "Simulacra." Flash Art [No. 110, Jan. 1983]: 38-40.

Nuñez-Fernández, Lupe. "Out of the Shadows." Art Review [Vol. 62, March 2006]: 76-79.

Politi, Giancarlo and J.L. Allexant. "Paris Biennial." Flash Art [No. 58-59, Nov. 1975]: 14.

Slyce, John. "John Stezaker." Art Monthly [No. 282, Dec. 2004 - Jan. 2005]: 35-36.

Smith, P. "Conversation with John Stezaker." Studio International [Vol. 189, No. 974, March - April 1975]: 130-132.

Stahel, Urs. "Aspects of Contemporary Swiss Art Photography." History of Photography [Vol. 22, No. 3, Autumn 1998]: 254-260.

Stezaker, John. "John Stezaker: Premises." Flash Art [No. 40, March - May 1973]: 16-18.

Tagg, J. "John Stezaker." Studio International [Vol. 191, No. 981, May - June 1976]: 309-310.

Taylor, Brandon. "The Avant-Garde and St. Martin's." Artscribe [No. 4, Sept. - Oct. 1976]: 4-7.

Taylor, Brandon. "Photo/Montage." AICARC: Bulletin of the Archives and Documentation Centers for Modern and Contemporary Art [No. 29-30, 1991]: 47-55.

Thomas, Michael J. "The Game-as-Art Form: Historic Roots and Recent Trends." Leonardo [Vol. 21, No. 4, 1988]: 421-423.

Walker, John A. "A vexed trans-Atlantic relationship: Greenberg and the British." Art Criticism [Vol. 16, No. 1, 2001]: 44-61.

Selected Writings by the Artist

Büchler, Pavel, ed. *Conversation Pieces*. Manchester: i3 Publications, 2003.

Hetherington, Paul. *Artists in the 1990s: Aspects of the Fine Art Curriculum (Issues in Art and Education)* London: Wimbledon School of Art in association with Tate Gallery, 1996.

Selected Collections

Arts Council England, London, England
Ellipse Foundation Contemporary Art Collection, Cascais, Portugal
Maja Hoffmann Collection, Basel, Switzerland
Michael Rabkin and Chip Tom Collection, Los Angeles, CA
The Museum of Modern Art, New York, NY
Rubell Family Collection, Miami, FL
Saatchi Collection, London, England
Sammlung Deutsche Bank, Frankfurt, Germany
Tate Collection, London, England

Checklist

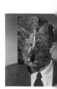

Blind, 1979
Collage
Image size: 7 5/8 x 9 1/2 in. (19.4 x 24.1 cm)
Paper size: 7 7/8 x 9 7/8 in. (20 x 25.1 cm)
JS1
pp *12*, **46-47**, 112, 115, *126*

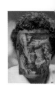

The Trial, 1980
Collage
Image size: 7 5/8 x 9 5/8 in. (19.4 x 24.5 cm)
Paper size: 7 3/4 x 9 3/4 in. (19.7 x 24.8 cm)
JS2
pp *13*, **50-51**, 112, 115, *126*

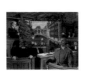
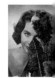

Tabula Rasa II, 1983
Collage
Image size: 5 7/8 x 7 3/4 in. (14.9 x 19.7 cm)
Paper size: 6 1/8 x 8 1/16 in. (15.6 x 20.5 cm)
JS3
pp *16*, **54-55**, 112, 114, 117, 119, *126*

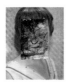
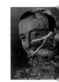

Mask II, 1991-1992
Collage
Image size: 10 x 7 7/8 in. (25.4 x 20 cm)
Paper size: 10 3/4 x 8 3/8 in. (27.3 x 21.3 cm)
JS4
pp *18*, *26*, **59**, 113, 115, 116, 118, *126*

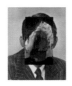
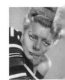

Mask IV, 2005
Collage
Image size: 8 1/8 x 6 1/2 in. (20.6 x 16.5 cm)
Paper size: 9 1/2 x 7 1/4 in. (24.1 x 18.4 cm)
JS5
pp *19*, **63**, 113, 116, 118, *126*

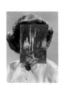
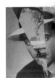

Mask V, 2005
Collage
Image size: 9 3/8 x 7 in. (23.8 x 17.8 cm)
Paper size: 10 x 8 1/8 in. (25.4 x 20.6 cm)
JS6
pp *19*, *28*, **67**, 113, 116, 118, *126*

Bold—Plates / *Italic—Editorial* / Standard—Installations

k VII, 2005
age
ge size: 8 1/4 x 6 7/8 in. (20.9 x 17.5 cm)
er size: 9 1/2 x 7 1/4 in. (24.1 x 18.4 cm)

8, 26, **71**, 112-113, 115, 118, *126*

k VIII, 2005
age
ge size: 9 1/2 x 7 3/4 in. (24 x 19.7 cm)
er size: 10 5/8 x 7 7/8 in. (26.7 x 20 cm)

8, 27, **75**, 113, 115, 116, 118, *126*

Portrait (Landscape) VIII, 2005
age
ge size: 9 3/4 x 7 3/4 in. (24.8 x 19.7 cm)
er size: 13 5/8 x 10 3/8 in. (34.6 x 26.4 cm)

0, **79**, 117, 118, *126*

Portrait (Landscape) XI, 2005
age
ge size: 9 5/8 x 7 3/4 in. (24.5 x 19.7 cm)
er size: 13 x 9 1/2 in. (33 x 24.1 cm)

0, **83**, 117, 118, *126*

Portrait (Incision) III, 2005
age
ge size: 7 3/4 x 7 1/8 in. (19.7 x 18.1 cm)
r size: 13 1/4 x 10 1/8 in. (33.7 x 25.7 cm)

19, **87**, 117, 118, *126*, **Back cover**

Portrait (Incision) VI, 2005
age
ge size: 9 1/4 x 7 5/8 in. (23.5 x 19.4 cm)
r size: 11 1/8 x 10 1/8 in. (28.3 x 25.7 cm)

ront cover, 6-7, *20*, **91**, 117, 118, *126*

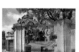

Film Portrait (She) V, 2005
Collage
Image size: 8 x 7 3/4 in. (20.3 x 19.7 cm)
Paper size: 11 3/8 x 8 5/8 in. (28.9 x 21.9 cm)
JS13
pp *21*, **95**, 113, 116, 118, *127*

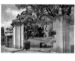

Cinema 2 I, 2005
Collage
Image size: 7 7/8 x 11 5/8 in. (20 x 29.5 cm)
Paper size: 9 1/2 x 13 in. (24.1 x 33 cm)
JS14
pp *15*, **98-99**, 112, 115, 117, 119, *127*

Cinema 2 II, 2005
Collage
Image size: 7 1/2 x 11 7/8 in. (19.1 x 30.2 cm)
Paper size: 9 1/2 x 13 in. (24.1 x 33 cm)
JS15
pp *15*, **102-103**, 112, 115, 117, *127*

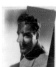

Untitled, 2007
Collage
10 1/4 x 7 7/8 in. (26 x 20 cm)
JS16
pp *21*, **107**, 112, 114, 117, 119, *127*

Untitled, 2007
Collage
11 1/4 x 8 in. (28.6 x 20.3 cm)
JS17
pp *21*, **110**, 111, 114, 117, 118, *127*

Mark Coetzee has been the director of the Rubell Family Collection since 2000. He is originally from Cape Town, South Africa, where he set up the Fine Art Cabinet, a non-profit space, where he curated over 60 exhibitions. Coetzee has published extensively on art, writing for journals such as the Mail and Guardian, Revue Noire and the Sunday Independent. He has published over 30 monograph catalogues on various artists. He has received various grants and awards for his work from foundations such as: Arts and Business Council of Miami of Americans for the Arts, BASA (Business & Arts South Africa), Harry Crossley Foundation, Human Sciences Research Council of South African, Maggie Laubscher Foundation, Miami Design Preservation League, Ruth Prowse Foundation, Irma Stern Foundation, Montague White Trust, National Arts Council of South Africa and the W.K. Kellogg Foundation. His latest publication is *Not Afraid* by Phaidon Press. Coetzee studied at the University of Stellenbosch, the University of Cape Town, and the University of Paris, Sorbonne.

Thanks

The Staff at the Rubell Family Collection: Registrar, Juan Valadez; Archivist and Assistant Registrar, Carolina Wonder; Designer, Chi Lam; Building Manager, Juan Gonzalez; Visitor Services and Bookstore Manager, Stephanie Garcia; Curatorial Assistants, Mark Clintberg, Kristi Mathews and Brooke Minto; Chief Preparator, Richard Kern; Preparators, Ricky Jimenez, Diego Machado, Paul Pisoni, Susanne Slauenwhite, Matthew Snitzer and Mark Stark; Museum Educator, Linda Mangual; Housekeeping, Sonia Alvarez; Proofreader and Text Editing, Elizabeth Martinez; Accounting, Liliana Zarif; Bookstore Assistants, Kiwi Farah and Cecilia Fernandez; Design Assistant, Sergio Alvarez; Office Assistant, Fanny Martinez; Conservation Interns, Anne Blazejack and John Witty; Visitor Services Interns, Yadian Fonseca and Jacob Guerin; Archive Intern, Katrina Miller

Matthew Higgs at White Columns, New York, for introducing us to the work of John Stezaker. Also to The Approach, London, especially Jake Miller, Emma Robertson, Mike Allen and Vanessa Carlos; and Yvon Lambert Gallery, New York and Paris, especially Yvon Lambert, Olivier Belot and Luisa Lagos.

$30.00

ISBN 978-0-9789888-3-8

EAN

9 780978 988838

53000>